C000049775

THE GREAT BRISTOL HIGH STREET

Glorious Gloucester Road

COLIN MOODY

The History Press

First published 2020

The History Press
97 St George's Place, Cheltenham,
Gloucestershire, GL50 2QB
www.thehistorypress.co.uk

British Library Cataloguing in Publication Data.
A catalogue record for this book is available from the British Library.

ISBN 978 0 7509 9249 7

Typesetting and origination by The History Press
Printed in Turkey by Imak

INTRODUCTION

This book celebrates the people of Gloucester Road in Bristol: the shoppers and traders who make it the vibrant and thriving cornucopia of independent businesses that is home to one of the longest runs of independent shops in the UK. As a photographer, I am constantly drawn to this energetic environment, which has unfailingly rewarded me with a myriad of opportunities to create a visual record of the Road and the people who live and work there, who generously engaged with me from day one of this project.

I've been welcomed, advised, guided, helped and fed by so many who wanted to share their thoughts on the Gloucester Road and what makes it tick. I wanted the photographs to speak for themselves, but early into the project I started to conduct research interviews and it quickly became apparent that these conversations would work well in tandem with the images. These transcripts are drawn from those who live and work along the Road.

Insightful conversations shaped the project and guided my creative practice to take images that aimed to get under the skin of the Road. I did not seek to add elegant touches to the photographs in order to present a stream of glossy magazine-styled images. Inspired by Henri Cartier-Bresson's concept of the decisive moment, I believe that good documentary photography is about boldly

capturing a dynamic image that conveys a glimpse or essence of something deeper under the surface. I hope that this collection of photographs has come somewhere close to capturing the essence of the Gloucester Road.

There is a deliberate ambiguity at the core of this photography story. I want these photographs to prompt more questions than offer solutions, leaving hints of stories and lives unwritten to encourage more engagement. Perhaps, when all these photographs stack up in this mixture of street photography and portraits, we might come to our own conclusions about what we mean by 'community' and how we belong.

There were a thousand possible routes in to making this book and I let myself be guided by the traders I met. Every shopkeeper recommended at least two others for me to speak to. The composition of each image is an art form, but placing the photographs in pairs and ordering them for the book was a challenge I relished. With one image your eye moves across it; a whole book and it's your mind that reads it.

Painted portraits of individuals hang in castles and abbeys, they say 'we were important'. A simple gesture with a hand in one, or a look in the eye in another confirms the sitter's uniqueness and status, and the viewer marks every detail of that person in their mind. I wanted to celebrate the people of this road who tirelessly serve something bigger than themselves – their community – everyday, with dignity and respect.

There are images of protest alongside those of the day-to-day life of Gloucester Road, which reflects that deep down there are struggles here. Things are often stranger and more complex than they first appear, and life is often hard work. The imperfect and messy are visible in my photographs, as it is the flaws that often reveal tantalising glimpses of the perfect. Photographically I am keen to break the rules, do things a little differently, so I was pleased to find many rulebreakers from all walks of life on the Gloucester Road.

I've used a few shots from the ballet school here and there in this story because dancing through a rehearsal space became, for me, a ballet about life on the street. These photographs mark moments where I am asking you the viewer to think about boldly stepping out into this story, I'm asking you to engage. The photographs in this book are full colour because the here-and-now feeling is vital to delivering the message of the book. Black and white would, even if only used once, create nostalgia. I prefer to look ever forwards, out from each page with these faces.

Many businesses you will see here are interdependent on others just a page-turn away, and on many more that do not appear in this book. I shot over 2,000 images but had to edit these down to 100 for this project. Some say that light is your subject in photography, but it's always life. Do not stop shooting until you find what you are looking for. The last shot taken for this book is the man who demanded I photograph his favourite shop immediately, despite the fact that we were having a pint in a pub at the time. He may look aggressive at first glance, but look twice and you'll see that it's passion. And I knew it was a wrap after that shot because if there is one word that unites the people in this book, it's passion. So enjoy, meet many people face-to-face – just 150 or so of the folk who make up the traders, locals, tourists and passers-by of the Gloucester Road. Some shops are thriving, some closing or being ripped away from one trade and another being set up in its place, but right here, right now, with this book in your hand, all these people stand for what is the Gloucester Road.

ACKNOWLEDGEMENTS

My thanks go to Nicola and the team at The History Press for their passion and belief; my partner, Nancy Jones, who has supported my photography unconditionally and has helped to shape and edit my words, often at the last minute; Martin Parr for his guidance and advice and the technique of the 'fill flash' used extensively in this book to add a kiss-of-life to the portraits; Sarah Thorp, who came to the launch of my first book, *Stokes Croft and Montpelier*, and who said over a beer, 'you need to do the Gloucester Road next'; Deri Robins, editor of *Bristol Life Magazine*, who has continued to support my photography and Bristol stories; and to Visit Bristol for their support of my photography. But most of all, to the people of the Gloucester Road neighbourhood: you opened up your bakeries to me at 6 a.m., drove me to Cornwall to show me the fish you sell being landed and prepped, made me a proper hot chocolate when I needed it, massaged my head, let me bounce on the trampoline to get the shot, cut my hair, sold me my *Big Issue*, asked me questions like 'have you met Banksy?' in an impromptu interview for Jamuna Television from Bangladesh, in the pouring rain outside the cricket ground. You've stopped me walking into the traffic on more than one occasion,

held yoga poses for me, served me beer with a smile and even talked about how we all 'go away' in the end, in a unique way only found on this road, in this city, in this time and place. Thank you to each and everyone of you.

See you on the Road sometime soon.

Colin, 2020

CRAWFORD'S
NEWSAGENTS
OFF LICENCE
TOBACCONIST . CONFECTIONERY
PAY POINT . NATIONAL LOTTERY

theguardian

TheObserver

5:58 a.m. For 364 days a year, Chandra Patel is up early to get the papers sorted for his customers: 'We are providing a service to the community.'

Alan Bec FRSA, Life Scientist

Alan, can you break it down for me: sociologically, what is it about the Gloucester Road that people connect with in such a profoundly personal way?
Shopping here is a significant social act. Each of these independent enterprises is as different as the faces of the people living here. For me, it's this confident individuality that collectively creates the Road's living psychosocial energy. It is safe and friendly. A home for cultural diversity and expression. It's an invigorating experience, radiating subtle energy that fluctuates throughout the day, and every visit turns up as intriguingly fresh. The no-pressure vibe breeds an open, cooperative spirit where genuine consumer relationships flourish. I feel able to share my impressions and insights with complete strangers like we are friends. The characteristics of the shopkeeper, the energy exchange between people and place is a transformative series of experiences that is an essential reminder of the human value in hanging out on the Gloucester Road.

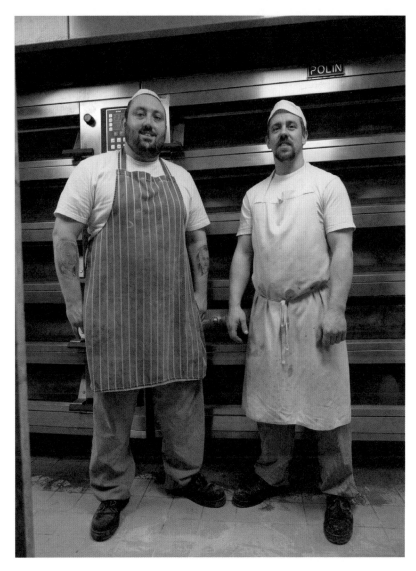

6:02 a.m. Baker Boys, Paul Viner (*left*, with his children's faces on his arm) and Wayne Thick, from Joe's Bakery.

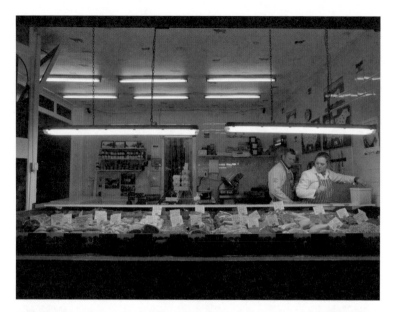

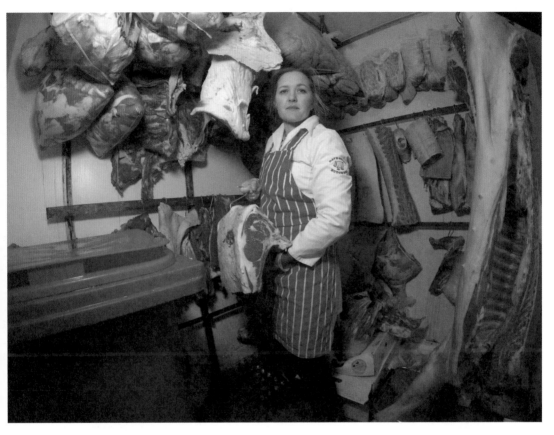

Amy Osborne, Dave Giles Butchers: 'I love my job, I love working with the lovely people of Bishopston and beyond. We support the local industry by sourcing everything from Bristol, Somerset and Gloucester.'

Opposite page:
6:35 a.m. Amy and butchers. Before you are normally awake the whole meat counter is prepped and window dressed.

Pigs on the shelf.

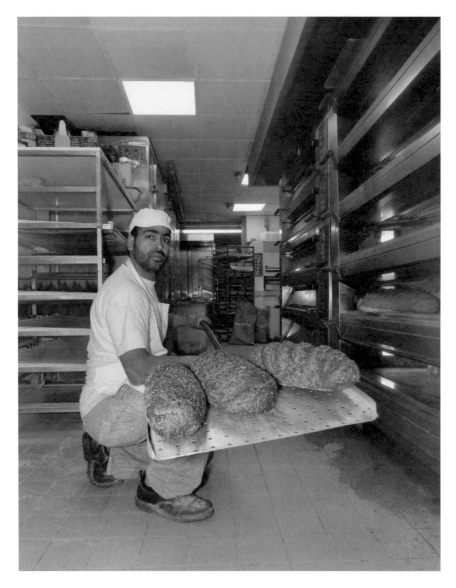

7:05 a.m. Joe's Bakery. The smell in here is divine.

Phil, window cleaner, often up and working in the summer before anyone else: 'We need more attention on what's up this end. A new pub would be good. It can't all be just coffee shops can it? That's not for everyone.'

Fraser, Ablectrics

Tell me about the Road …

If you were to just come with me, walk up the Road with me for 10 minutes while I picked up my bit of food and my stuff for the day: going into the fish shop they get the latest fish out from the coast and local for me, they know my name, there is a proper atmosphere and spark up and down the road. Go in the fruit and veg shop, everyone knows us, we all know each other's business in a good way. Butchers is the same. Everyday, I go out and get my stuff. I don't shop for the week, I shop for the day. And that's 'cause I've got the Gloucester Road on my doorstep. And I enjoy that. I could be in and out in two minutes, but I like having a chat. I like finding out what they are up to. Engaging with my local shopkeepers and the community around us. Hearing the pros and cons of what they are up to. What's gone wrong for them, what's going right. Subjectively offering some kind of help from time to time. I might take some flyers up for my sales and they put them out for me. It's just how it should be.

Compared to ordering online?

The internet does not reflect people. Business is people.

You told me you could run this whole shop cheaper out in a unit somewhere else. But you choose not to …

I will be the last guy with a lighting showroom on the high street if it kills me. I am determined not to … Look, I have a website. [Because] you have to. It's a necessary evil. A website is a tool. It's the devil's tool in my opinion, but I will be the last guy to engage with people in a showroom if it kills me. I will have to get dragged off this street kicking and screaming. 'Cause I like people. I don't like dealing with people on the internet. They only shout at you when their stuff has got broken or not arrived. And it is not me, it's the delivery company. When you get to chat to people in the shop you find out about their house, they all have a story, they all have a life. It's just interesting. If you are a people person, a showroom is the best place to do business.

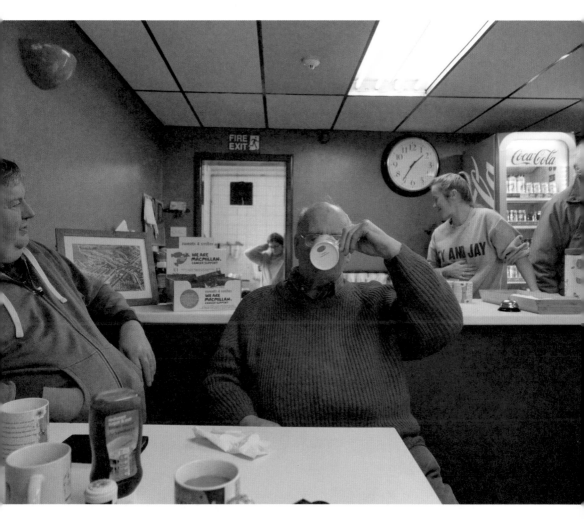

Ron, Steve and locals at the Metro Café having the first cup of tea of the day. Regular meet ups are held here daily.

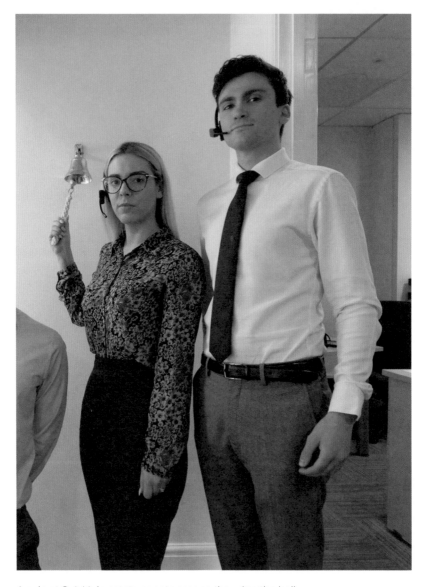

A sale at C.J. Hole estate agents means they ring the bell.

Diversity right at the top.

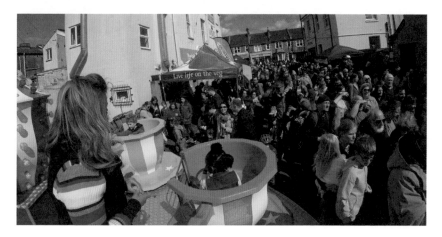

May Day.

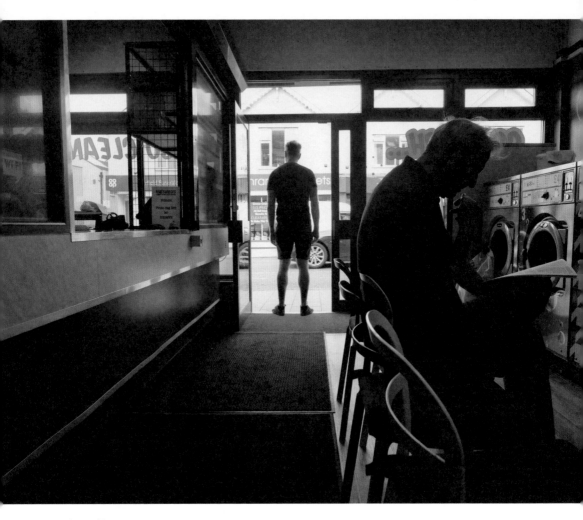

Laundrette life.

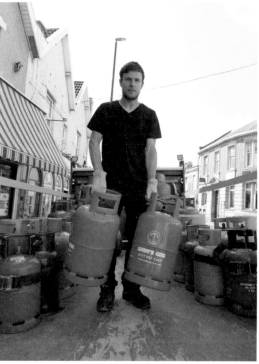

Community officers outside Totally Toys. Warren (*right*) and ... ?

Marlon, Andy's Gas delivery.

Franco, hairdresser, Vincenzo & Sons
(while I was having a short back and sides)

Give someone tips for their first trip down the Road.
What makes Gloucester Road special, as opposed to shopping in a supermarket, is that you go to the butcher, you might have recently moved in, you say you need something for a dinner party. 'I just want something simple, you know, that is gonna be good, to impress the guests,' you might say. Maybe they might suggest a joint. Tie it all up for you. Wrap it up [with a] little herb bundle, tell you to stick it in the oven. And then put some potatoes in with it and roasting veg, all in the same tin. Done. Dead easy. The good thing about that, a week later, two weeks later, when you go back: 'How did the dinner party go?' they will ask. Unlike the supermarket [where] it's just you and BLEEP BLEEP BLEEP ... and no one is gonna remember you are they? Whereas here people remember who you are. You are not just a bleep. And that's what I think people really, really like.

Opposite page:
Lovely pups. There's a place that keeps on calling me. Dooley (*right*) and Lianne (*left*, with whole of Bristol in tattoo form): 'Pretty [much] every restaurant and café on this street is dog friendly. I wanted to be part of the indy scene and six shops welcomed us the day we set up and as we opened the doors.'

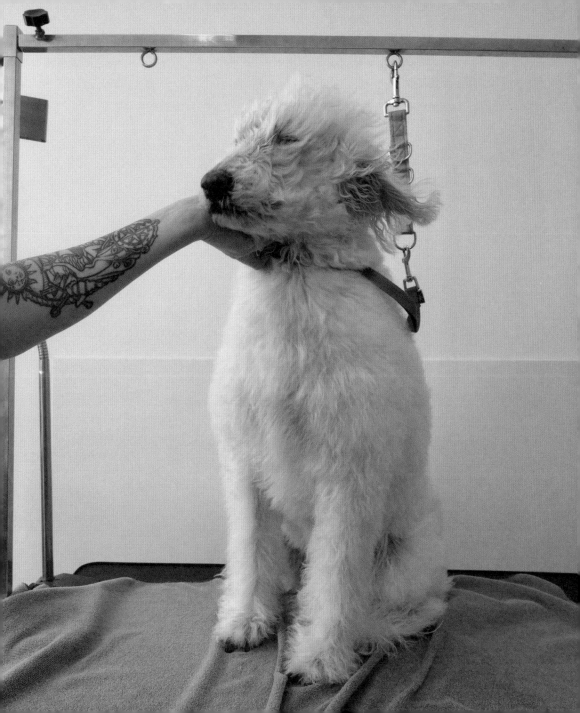

Asher and Gromit. The owner's daughter made it years ago and now she has a career in the arts.

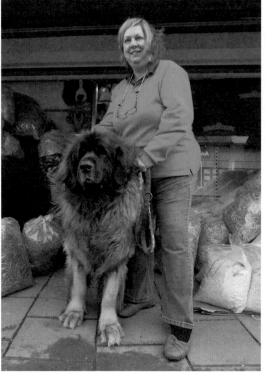

Sarah Barrett (voice of the cockatoo on 'Creature Comforts') and Massey, a 98kg Leonburger, the biggest dog on the street, at Roxfords. The shop owner added an 'R' to the shop name when taking over the 'Oxfords' business back in the day. So Bristol.

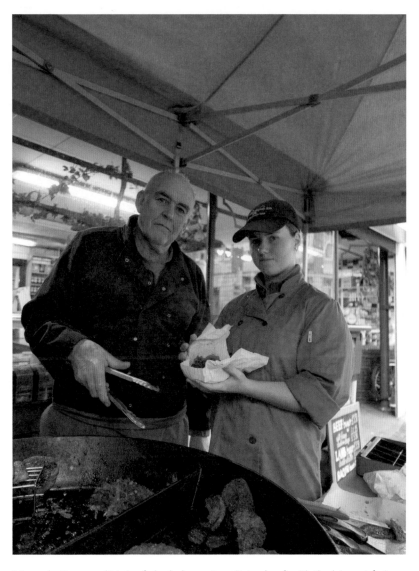

Murray's. Dean and Maisy (who helps out on Saturdays) with the biggest frying pan in Bristol, made in Germany.

Shop closing. Terrii and Tom have four weeks until departure.

Opposite page:
Blacksmiths Fred Brodnax and Martina. They make everything: 'We are in the perfect place for this kind of business here. If we can't make it, we send them to the local shop just a stone's throw away.'

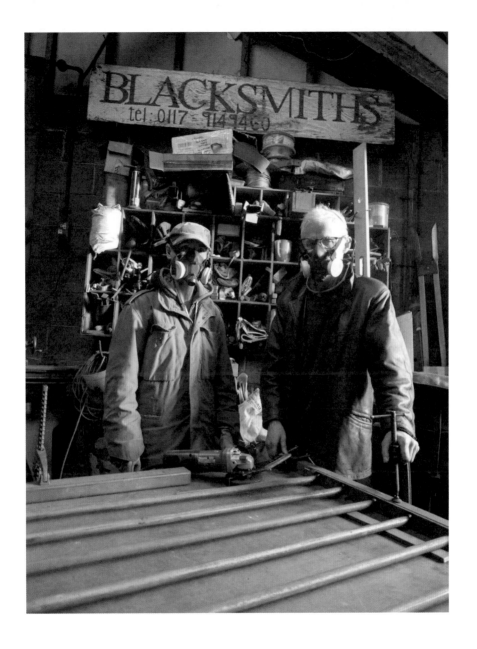

Eleanor Combley, Green Councillor for Bishopston and Ashley Down ward 2019

Tell me your experience of this road in your life.
I would walk down to the Gloucester Road and I would buy our bread, meat and fish and vegetables, and some days [when] you are a young mum at home with the kids, that's the only conversations you have. It's a place to go to and it's a place to be with other people. I think if we lost it, that would be tragic for this area. That is the reason people want to live in the houses just off Gloucester Road. In my own street we have older couples from families that have been here forever. Their kids went to the local schools. They are still living in the local area. Then there is my generation that bought a place here in the early 2000s, who are maybe one or two professional incomes in the household. Just about managing to afford to buy and live around here.

Say something about your move here?
When we bought our house, it was the furthest into town that we could afford to buy a place with a garden. So that's how we ended up here. Now, the people who are buying in my area, as the old couples move in to nursing homes or die, it's like two doctors, or an engineer and a solicitor. Two good salaries, that's what is determining who moves in to the area. I think busy people are very tempted by the ease of ordering things off the internet, but the experience of shopping and seeing other real humans and being part of something as important as Gloucester Road is what draws us in. I know people, they will walk down Gloucester Road with their kids on a Saturday morning and they will maybe buy a magazine for the kids, some playing cards or whatever it is the kids are in to at the time. It's an experience, it is a day out. It is something to do here.

Any stand-out moments when you realised it was special here?
For me, I remember one year I was feeling really fed up of the whole issue of Christmas. The struggle of trying to buy something that would entertain and amuse everyone and the 'stuffness' of it all, but I came down the Road and every conversation I had on that day was a real conversation with a real person and I realised I had just been shopping in the wrong place, and that Christmas was not such a bad idea after all.

Any negatives we should look at?
Regards the bus stop billboards and out-of-town advertising … Well, I think that is relentless and that will keep on coming at us. I think there are moves in planning law to make it more difficult for people to produce those pretend phone-booth digital billboards and in Bristol there is a strong movement to resist that. There is a reason people advertise and it's because it makes them money. I don't think we will stop it overnight. We just have to stay sane. Look. Walk into the first café you come to and just sit down for a little while and watch the world go by because there is no better place to do it.

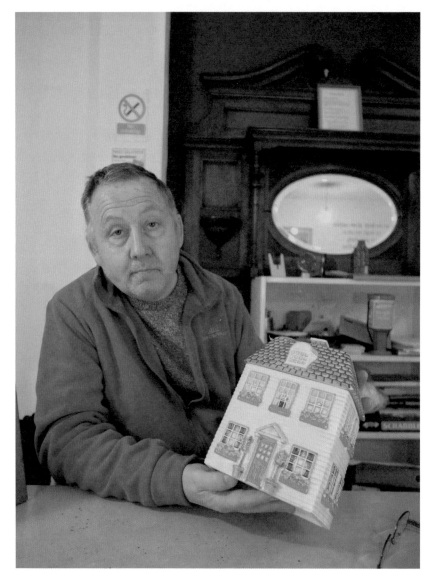

Nigel of Emmaus Vintage.

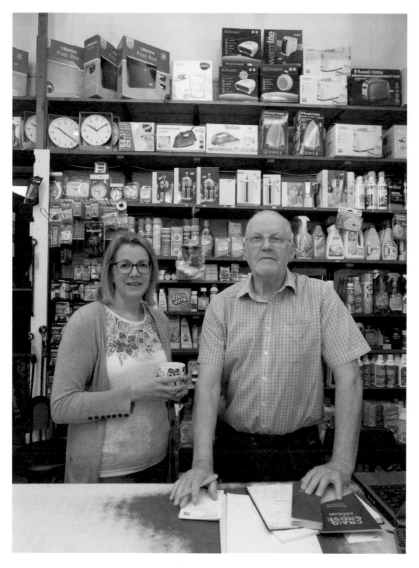

Bishopston Hardware, a family affair. Bryan: 'We set up in 1972. We saw the big DIY stores off. We have not changed, and that's what people like.'

Woolworths, then Peacocks and finally Digger World. Passer by as I was shooting: 'I see empty shops like this and I worry about the future ...'

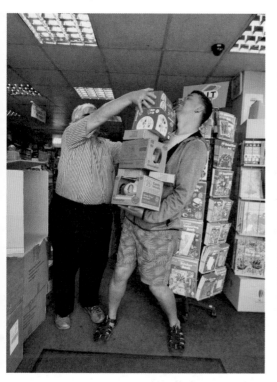

Stacked. Jason and Paul of Totally Toys.

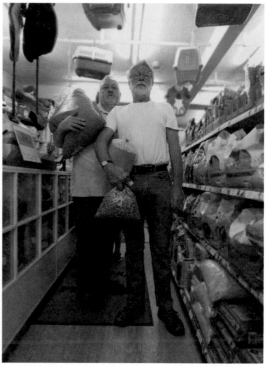

Renaissance men buy hamster mix in bulk at Roxfords.

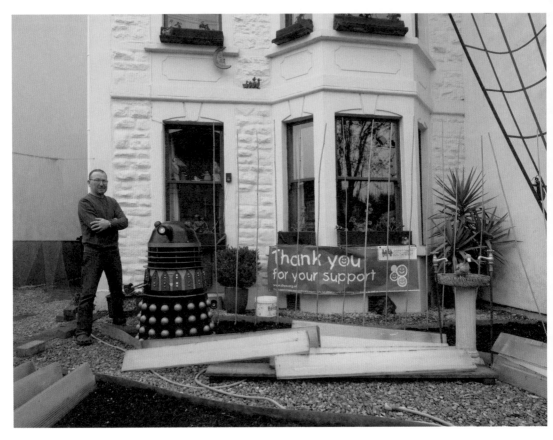

Keith Walker, fundraiser: 'This Dalek's been here for twelve years. It's a council compost bin, a wok and some bits from Bishopston Hardware.'

Smile, you're on CCTV.

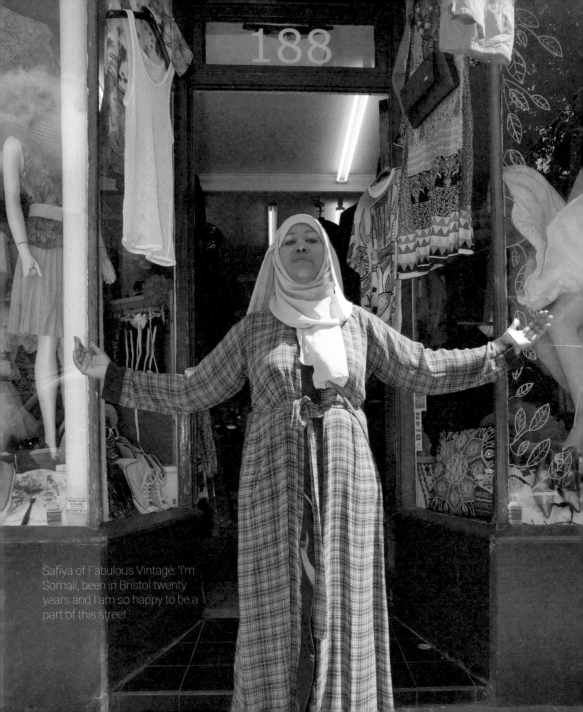

188

Safiya of Fabulous Vintage: 'I'm Somali, been in Bristol twenty years and I am so happy to be a part of this street.'

Dee, Divine Ceremony

Funerals I see a certain way. There is a tradition to how they are done, maybe even how we behave and deal with death. I wanted to talk to you about what changes when we attend a funeral.

When you arrive at a crematorium or burial ground, or ceremonial space, the moment you cross that threshold you leave your ego at the door. It's the one space, confronted by mortality, where the mask that you wear every day in your daily life can't be worn. You will be confronted by the reality of the physical situation and a whole dynamic of emotions that require you to think in a different way. There is only space for the here and now; there is no space for the stuff of your life. I love the process of a ceremony. Ceremony leads us somewhere. To each other. The process is that you come in with one kind of grief. Grief is physical. You can see it.

Take suicide. When the coffin comes in the grief that follows with the mourners is a very physical thing. Suicide is spiky. There is an undertow of slight anger. There are so many questions. The ritual happens and we reform that grief and we leave in a different way. As we go out together, hopefully the spikes aren't there anymore.

What about a generation now that shares so much on social media? What can we do for a generation that seems to be almost diverting its attention away from thinking about death by living in a perfect now all the time?

For me, it was to open a brand-new style of undertakers at the beginning of a major high street and be totally unashamed about that.

This place you have chosen was where all the tramlines intersected; it was a hub. It's no accident you have chosen here, is it?

This space is the gateway of Gloucester Road. I wanted to find the right place for my space. There is something about it having been a bank beforehand. It was part of the wealth of the high street. I feel that our death stories, our life stories, that's [*sic*] also our wealth. You can't take anything else away with you. I've never heard anyone at a funeral say they were so grateful, that they were so glad they worked hard all their lives. Never. But I have heard people say how 'she would have loved it if she could see how many people were here'. If only people had been able to hear what people had been saying about her while she was alive.

Where you are, people will pass by, and on the top deck of the bus people are on their phones, but when they do look out and see your business how are you going to get through to them that it's time to start thinking about life and death?

Two point seven seconds is all I've got. The sign will be looked at for 2.7 seconds. But simply by me being here, and being part of the community, it works. We could, for example, have a 7 a.m. yoga session in here. Why not? Why not a wake while you are awake. Most funeral companies offer packages to their clients – hearse, coffin, flowers – and I don't think they always meet the needs of people. Flexibility is what people need at a time like this. Informed choice based on options tailored to the individual is probably more helpful. This process doesn't have to be about money. This is about how we – with our words, with our togetherness, with our spaces – say goodbye, and honour a life lived in the most appropriate way possible.

There are traders on this street who have been here for many decades. When they die, a 'to let' sign will go up. But if you are going to hold a whole street together, one as long and as independent as the Gloucester Road, how do you make sure a ceremony takes place to honour in a Gloucester-Road way?

Robin's funeral is a really good example of a ceremony that took place in a Gloucester-Road type way. Robin had worked at Bishopston Hardware for years

and years – he was well known and loved by his colleagues. He was local and had lived and worked around Gloucester Road – had raised his kids here. When he died, we held his funeral in his garden [as] it was so appropriate, being surrounded by his plants and the garden he loved. It was a crisp autumnal day and a hundred people were packed into the garden, and the ceremony took place there. That ceremony has not been forgotten by those who attended. When I was doing the fit-out for this shop, I used Bishopston Hardware a lot. They were so helpful, and I tried to buy most of my materials from local suppliers. Bishopston Hardware is like a church. Everyone who needs anything doing to any of their houses goes to Bish Hardware. Whenever I walked in, I rarely carried anything out to my car, because they knew I had done Robin's funeral. That's the Gloucester-Road way.

You talked earlier about spiky energy at a funeral, this is sounding like the opposite. People growing and binding together.
People are now asking me how they can do funerals differently. Bristol is this wonderfully liberal city and yet, until recently, we have been dying very conservatively. It is time now for us to think more deeply about how we say goodbye in a way that fully supports those of us left behind, but, importantly, truly honours the way someone has lived.

For me, this is about encouraging people to have the difficult conversation about death and dying. What do you want to happen in the event of your death? It is such a gift for a family to truly know what someone wants to happen after they have gone. It takes the pressure off everyone to understand that what they are planning is exactly what their loved one wanted. On a personal note, I know it informs the way I live my life – I don't sweat the small stuff anymore. There's so much to live for ...

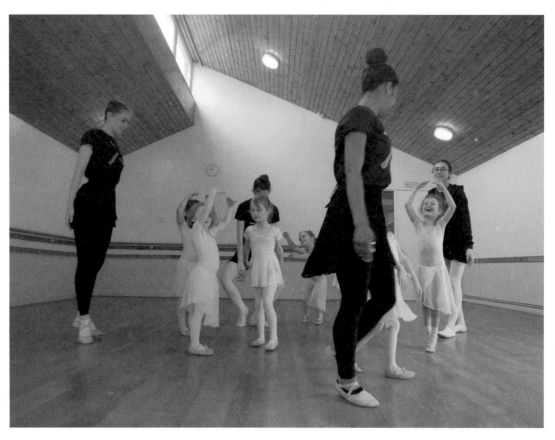

9:04 a.m. First class of the day at Annette Adams School of Dancing.

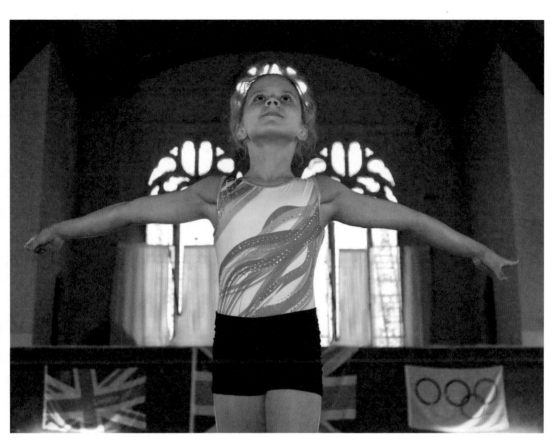

Bristol School of Gymnastics.

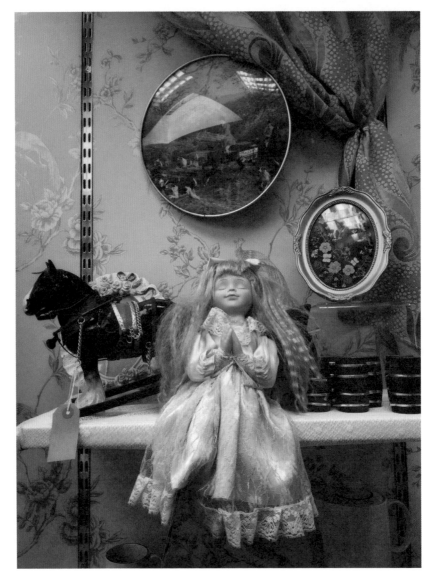

Charity shop's accidental shrine to the past.

Offerings. Thanks to Kelsang at the
Amitabha Kadampa Meditation Centre for
sharing this space where people come from
all walks of life for peace and happiness.

Garvin Hickey, co-owner with Vincent Crocker of the Drapers Arms

How long have you been here and what are you hoping to achieve with this place?

We've been here [for] three and a half years, and really it's that Vince was a brewer, had his own brewery round the corner from here, and he wanted an outlet to sell his beer. That's how it started. I worked in pubs and I've been in the pub game a long time. But I didn't want the whole full-on sixteen-hour day and I read about micro pubs, which are small, mostly ex-shop units where you have limited hours, no music, no jukebox, no phones, all about beer and conversation. I thought that sounded like the kind of thing I thought I could live with, so we looked around and we found this old shop. It was a drapers shop for a hundred years on the Gloucester Road. [We] took it over, opened in December 2015.

Very simple. People come in, we get good local beers, we can go a bit further afield. We always try to have between seven and twelve beers on every day. We don't sell lager, no keg beer, no cider, just cask beer. We do gin and tonics and we do wine. And that's it. And crisps and snacks. You can have chicken and chips, which is a pickled egg and a packet of crisps. Very simple. Simple hours. Place you can go for a pint after work, meet a few friends. Place to go before you go off for a meal, or downtown. It's a good spot. By closing at nine thirty, we've created an environment where we think we got it right. You've not got the people who have gotten [*sic*] stuck into a night's boozing, making a big session of it. At the end of the evening you have these people all shouting. The one thing about this place is that people do like to talk and you have an immediate conversation. One person asks you what are you drinking, what's that like? I don't know. If you go into a normal pub and someone is drinking a pint of lager you don't start talking about the lager. I don't know. Maybe you do.

Do you think Gloucester Road is looking back to go forwards? In stop-and-chat places like this, are we teaching ourselves about community all over again?

The council are concerned, I think, that the Gloucester Road is going to lose what's considered to be its uniqueness. They are nervous about it changing from a community-based place to a sort of another Stokes Croft, where it's all late-night drinking and bars. They are trying to keep the flavour of our road by having a mixed commercial use, lots of regular daytime shops, you've got cafés for day and bars for night. I don't think Stokes Croft is much fun during the day. And if you don't want to go drinking in a kind of loud environment it's not fun there at night. Part of this is why it was difficult to get a license on the Gloucester Road. Wetherspoons have been trying to open for years, but the council are knocking them back all the time. They think that will take something away from the unique independent ethos and feel of the road. But what do I know?

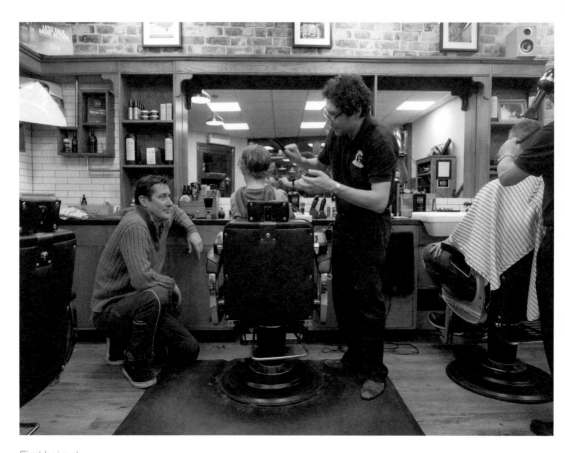

First haircut.

Cricket World Cup's unofficial face painter.

Hannah Rooke, of Wex Photo Video, sorting the colour rolls: 'This place has given me a platform to improve and gain confidence.'

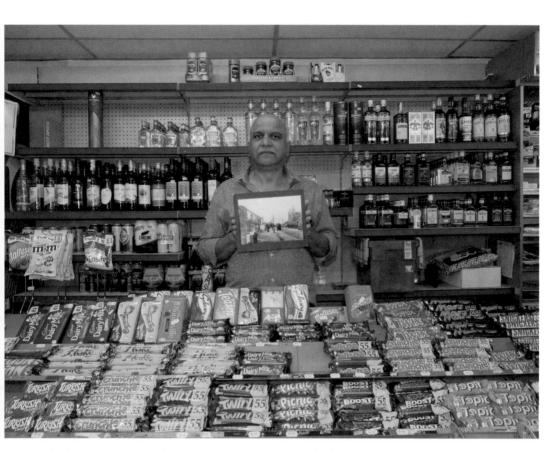

One hundred years ago ... Chandra Patel can take you through the last 100 years of his shop's history.

Melissa Chemam, writer, reporter, radio producer

You came here in 2015, what attracted you to the Gloucester Road?
What attracted me was not the Suspension Bridge or the Balloon Fiesta. Let's be clear. What brought me to Bristol was its immigrant population, by the means of the music scene inspired by Caribbean sounds, American hip-hop and later on middle-eastern rhythms. Having lived myself in Central Europe, Florida, East and Central Africa, as well as London and Paris, I was looking for a new tribe of fellow travellers and wanderers, inspired by places and people of all kinds of backgrounds. I knew of the Caribbean culture of St Pauls, and when I first came, I stayed on Brigstocke Road. It didn't take me long to arrive on Gloucester Road. I remember my first impression vividly: a humid day in February, walking up and down, from [one] independent café to another to write and work. I loved that, unlike London, Bristol didn't thrive on chains.

Can you be more specific?
In one of the cafés I interviewed people I couldn't meet in Paris over the phone, because I had already become enamoured with Bristol and wanted to spend as much time as possible here. One of them was a Turkish writer, talking to me about the lack of rights of Kurdish and Armenian communities in Istanbul, where I was due to go the first week of March. A few hours later, I stopped in front of Bristanbul, the Turkish bakery.

I walked further down the curvy street, the longest street of independent shops in Europe. I walked there a year later toward St Andrew's to meet a member of the reggae band, Black Roots. And I discovered further and further its multilayered communities, a mix of Somali and other African and Muslim cultures. I came to listen to my friend Lady Nade sing, at the Golden Lion, or more recently to report on the use of the Bristol Pound in local shops.

Take me down the Road, your way.

Stores and pubs held by people from the neighbourhood, making it come alive, working with passion, from the Gallimaufry to the vintage clothes shops. I like that people smile and greet each other when they cross paths. I love that they strive to make their neighbourhood stay alive and fight to preserve their independence and connectedness. This street is, to me, a reflection of Bristol's recent social changes. Gloucester Road looks, like an English mini-Berlin: edgy but genuine, with its own 'Kreuzberg' and its historically charged vibe in the architecture, heritage of the colonial times. This is why my itinerant self keeps coming back to this place, but more importantly to its special, generous, open-minded people. You might look for them on Bristol's curviest streets, where new twists in culture luckily seem ever possible.

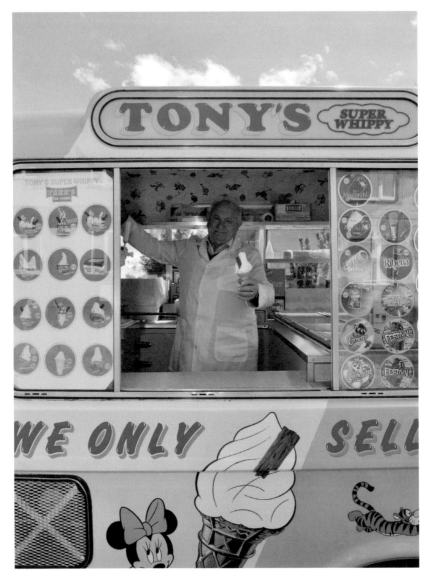

Tony's, served by Carmelo.

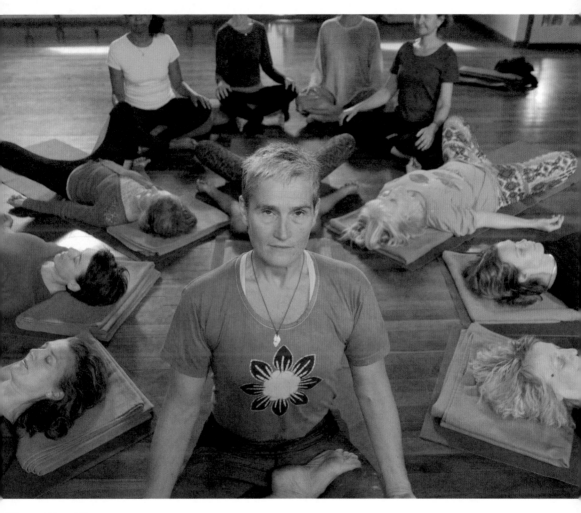

Diana at YogaWest.

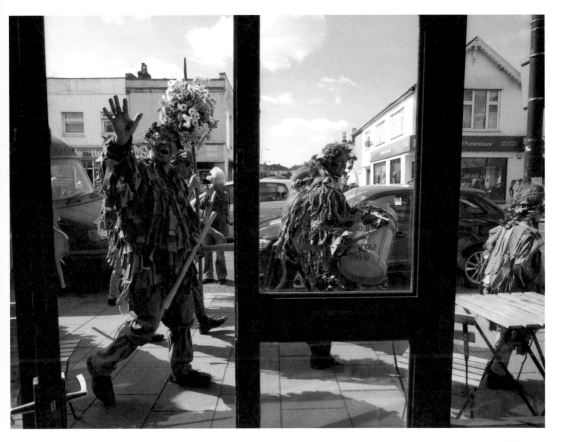

The Green Man approaches. Bristol's Jack In The Green welcomes summer each year, pit-stopping all the way from Harbour to Horfield Common.

Opposite page:
Dee Ryding waiting for the celebrants to arrive at Divine Ceremony set up at '... a five-way junction, the gateway to life on the Gloucester Road.'

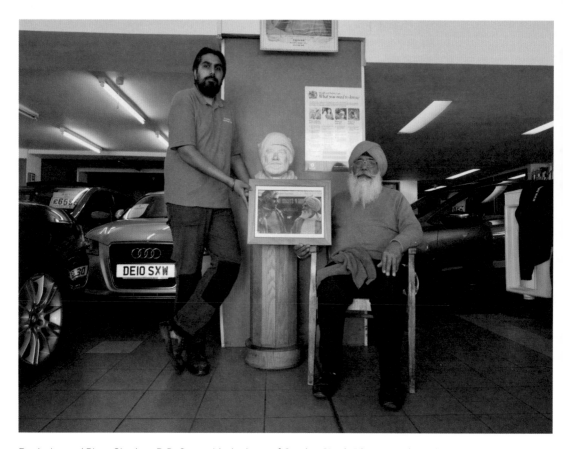

Ravinder and Piara Singh at P. D. Cars with the bust of Gurdev Singh Dhinsay. When showing this shot to elders at a day centre to test reactions to the images during the book's pre-production, Margaret Partington said, 'Say thank you to them for all the years of service they gave me please. They collected my car from my work and delivered it back all serviced before the end of the day and I am still driving at 88.' They were thanked.

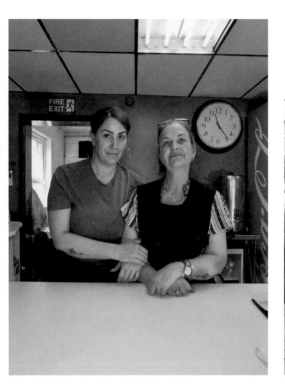

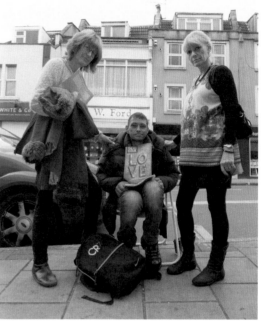

Kim and her daughter at the Metro Café. 'This place means everything. Been here sixteen years. If old fellas don't come in for a few days I take them a dinner round, make sure they are ok.'

Community hot spot. *The Big Issue* seller Dean with Chandra and Jane. 'We need more people like Dean. He is a community service. Many elders I know get out of their home knowing they will be able to stop and chat with Dean.'

Myke Vince, Snazzback drummer

I've noticed the indy [independent] spirit on this street. Does that reflect what music you choose to play?

The thing is, for us, the Gallimaufry is particularly important as we've got a residency here every week. Which means that it's like in the golden days of jazz when an outfit might have a place where you can play regularly and develop your material, because you can test and push the boundaries. People expect you to be adventurous. This place is a foundation. In the past a lot of great jazz musicians needed a regular gig, rather than doing just paid gigs in places where you have to do all the crowd pleasers, somewhere where you can hone your art, your craft. Take it to the limit. And, ultimately, that is the material that becomes more valuable to culture and in the marketplace. Because that is original material. Many bands are doing this, and need these places.

The Road has this undulating curve at this point and right now it's as if people are just washing up isn't it? Mixing in with the regulars?

It's like a human beach here. These people outside sitting there are like boulders and then people passing get snagged on them like fish, when the tide goes out, they get caught in the rock pool for however long. And when the tide comes in at about midnight or so they can swim home.

In the meantime, while stuck in the rock pools, they get to listen to your jazz?

You just have to hope they are not in the rock pool with a nasty jellyfish. Down the other end, more towards Stokes Croft, there is the Leftbank as well. That's a great venue. Tom who books the bands there and Thursday nights they have a funk night. That's a big night there. Tom gets us in. They also have a brilliant music policy.

Do you all support each other in the band scene?

Yeah, yeah, we all support each other. Particularly for us Waldos. We do gigs together; we are like brothers. And sisters. We look out for each other, we support each other. When you are part of a collective scene and people recognise that people understand [*sic*] that it's about the culture of the city rather than just individuals doing it for themselves. I've been playing on the Bristol music scene since I was seventeen. I'm fifty-four now. Still at school when I joined my first band. Playing in the Tropic Club, which is down on Stokes Croft. It hasn't been there for years. Bristol has always been a great place for music. I ended up moving here just because culturally it supported me and what I wanted to do. I think that's exactly the same for a lot of other people. They come and discover and meet like-minded people. If you are a crazy dog or cat you want to go somewhere you can be yourself and you don't have to worry about freaking people out, you can just get on with it. Gloucester Road is really the symbol of that independence in a world of homogenised, conglomerate, corporate bastardisation, you know? This is what people want. People get sick of all the normal stuff. So, it's really important that we try and nurture this.

When this place was put together with James Koch he told me he thought of it as a community space. A place where people who helped him build it have already invested in it before it even opened. Is that set to continue?

Yes, he's regularly commissioning artwork, there is some new work in the restaurant. It's a whole set up. It's something that feeds back into itself. That's what we need in this commercial world. More closed circuits like this place. All the good s**t doesn't get sucked out by the vampires on the outside.

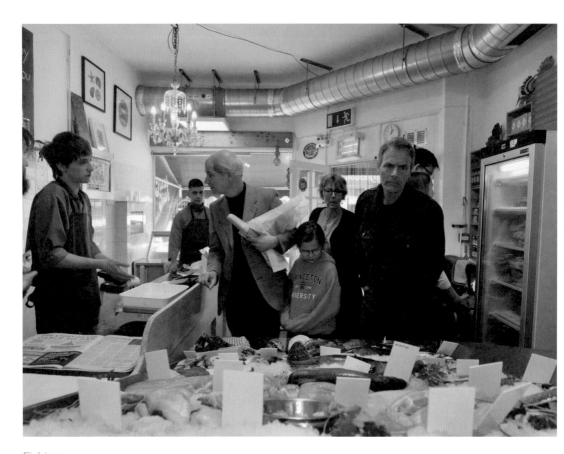

Fishing.

Opposite page:
Dan Stern, the fish shop man: 'We started in 2009, specialities from the south coast. We know the first names of all our suppliers.' Four weeks later he took me to Looe to show me.

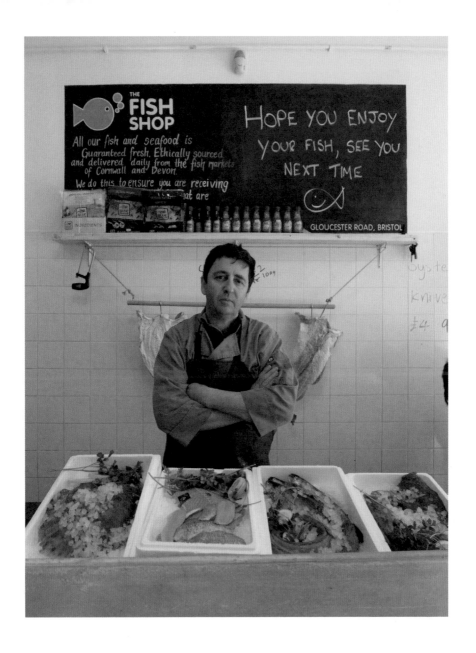

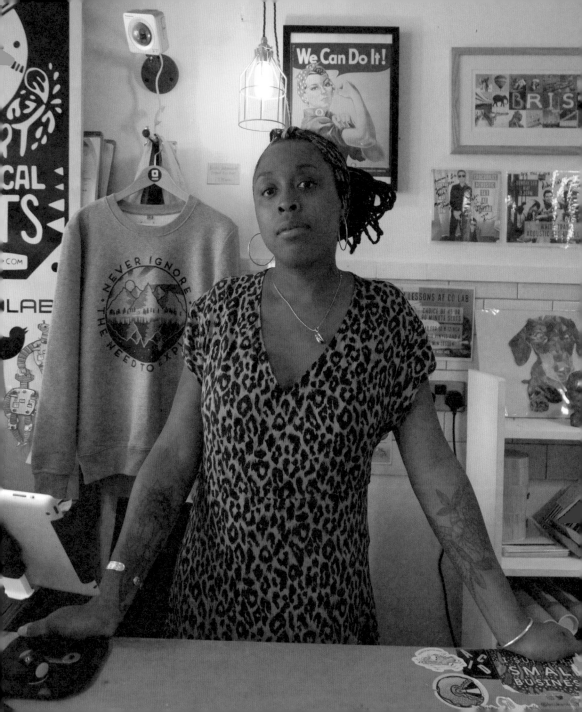

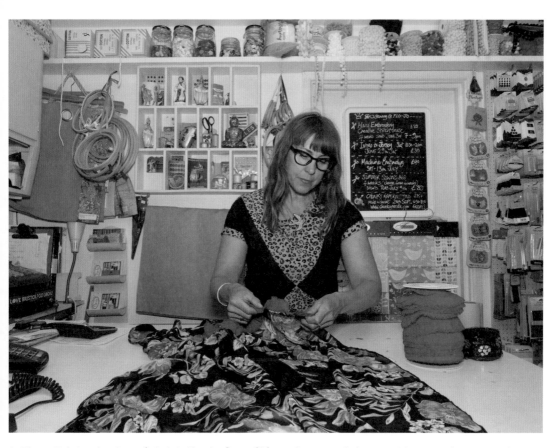

At Flo Jo Fabrics the river of cloth is like the flow of life up the street. 'It began with sewing lessons and people using the space, people wanting to get their bits and bobs sorted. School groups come and these kids know how to make and repair their own clothes.'

Opposite page:
Colab. Andrea: 'Having this place is really important to me. It's a way for independent artists, makers and designers to have a voice, an outlet. I also never imagined I would feel so welcomed by, not just the other shops, but also the community. It's a road that has its own unique feel that sets it apart.'

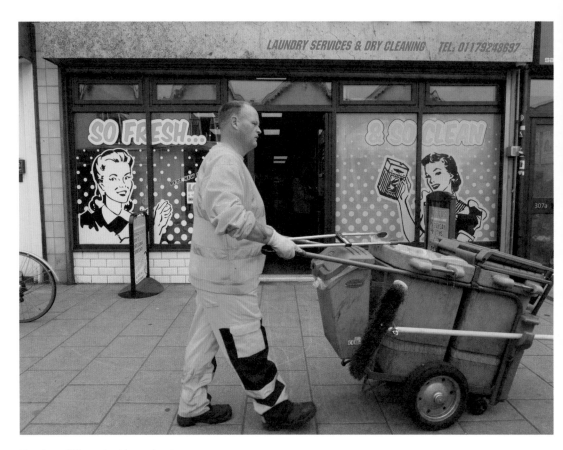

Fresh and Clean, inside and out.

Opposite page:
Are you being served?

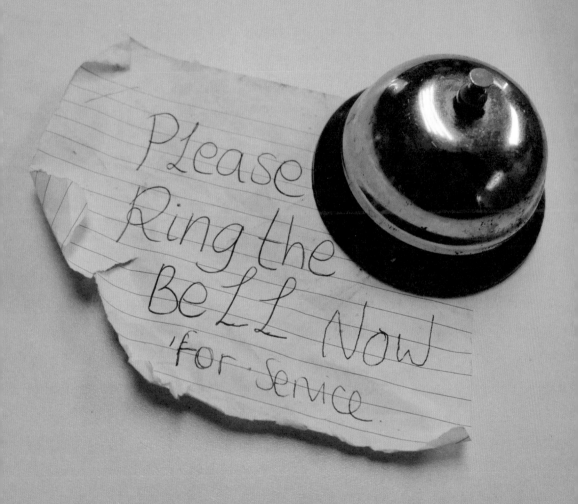

Sarah Thorp, Room 212 and Alchemy 198, Gloucester Road

How did this book happen Sarah? We had a conversation, didn't we?
I came along to the launch of your Stokes Croft and Montpelier book at the People's Republic of Stokes Croft, and I always thought that it would be great to have a book of the Gloucester Road. There are so many traditional shops and businesses that have been around for twenty/thirty-plus years, as well as cool new independent ones. As well as being a shop of artwork by Bristol artists, Room 212 is also my home and I've been living here with my kids for over six years. I've always been fascinated by who owned the business before and how the street has changed since Victorian times. It would be great to have a modern-day take on the Kelly's Directory. It would be a really great to have photos of the Gloucester Road as it is now, why people have their shops, their aspirations and dreams, customers who come in, community events we're putting on. I reckoned that if you've done a story of Stokes Croft you needed to follow it through and do Gloucester Road. The longest street of independent shops in Europe.

And here we are. You gave me some names and set up some meets for me: Amy the butcher from Dave Giles Butchers, Martin at Joe's Bakery, lots of businesses in this part of the Road. It was a start.
Dan at RollQuick, Sue at Pawson's fruit and veg. Newsagents ...

It was some of those shots from the first test day, that was when the book definitely started to form itself. Six a.m. and we got some very interesting stuff, to see the Road waking up very early in the morning. How do your mornings start?
I walk my daughter to school before I open the shop. Or I get up an hour early and go for a walk around the area. I don't want to just get straight out of bed and sit

down at my desk. So, I walk to work even though where I live is where I work. I like to greet the paperboy, or Sue getting the fruit and veg out, key cutters opening their shop. Also, lots of customers milling about or going to work. It's nice, that feeling.

I saw Phil, the window cleaner, up before everyone else the other day, getting those windows clean. If you wake up, as most do, after him, you see the Road a little bit shinier than it was the night before. It's a good start to the Road day, isn't it?
Yeah. And now I've got Alchemy we are not allowed to throw our glass bottles out into the bin after nine p.m., but the company that comes to collect them come at five a.m. That wakes me up seven doors up. But it's activity going on, keeping our street going. I'm sure you've met the team that goes around on a Sunday getting rid of tagging, scraping off stickers off the lampposts?

Yes, they didn't want to be photographed for the book. I can understand why.
Literally, last Sunday, there they were in the drizzle with raincoats on, older women with the scrapers, clearing the lamp posts. [TOOT TOOT. CAR NOISE] Ah, you can hear that in the background, can't you? The traffic.

I've heard from many traders how they are suffering because you can't park your car until a certain time. Rates and stuff. But what is it about the traffic for you?
Traffic is a real problem. I went to a meeting at the council yesterday about Clean Air Day [20th June] – a day to highlight the pollution in the city – and they say our children here are inhaling the equivalent of two cigarettes a day with the pollution that's coming out on the Gloucester Road. The EU recommended rates

were exceeded two years ago. It is getting worse and worse. People have to stop using their cars. Stop idling their cars. Have to use a better public transport system. Often there are big trucks parked up outside when doing deliveries. The other day this one truck had Organic Milk emblazoned all over the side of the truck, but the engine was on, idling for five to ten minutes. All coming into my shop and my lungs. We *have* to stop. You can bring your plastic containers and refill them at some of the amazing shops here, but it's no good if you use your car to do it.

This book is about the here and now. Marking the community and its interdependency, its many layers. We have seen stories of people who owned the shops before them and so forth, but when I was doing my research one thing that came up is that in ten, twenty, one hundred years from now, will the Gloucester Road still be as dynamic? The one thing that keeps coming up is the traffic. Parking and traffic. If it's not a safe environment to live and shop in, where does that lead?

I spoke to the guy in the van and he has to keep the engine on to keep the refrigerator working in the back. Really, in this day and age? Cycling? More cars is making that less safe. Pushchairs are right down at exhaust level. We all have to change our practice and thinking. We don't need to be driving out to big places because that's already been shown to not be what we want. Hypermarkets are not being built anymore. Small ones will do better. [SCREEEEEEECH. BREAKING TRUCK NOISE]

There is another big truck rolling up now. The recycling truck. That's interesting. Bishopston Hardware on the corner down the road, they 'saw off' B&Q one customer told me. At big stores they said you could not get the quick, instant customer service. Getting the right thing first time.

There is this guy who lives around the corner from here and he has been coming in ever since I opened. He comes in. He might buy a card. He might buy a print. But you can tell it's because he wants to have a chat. He tells me about his cat, his family. He meets the other artists who work here too. If we disappeared what would he do all day? He gets his paper in one shop, his milk in another, and that's his day started well.

In the mid 1990s, someone high up at one of the big three supermarkets was on Radio 4 talking about how the high street was dead. We needed to get used to shopping by car in these big out-of-town centres. What do you think he'd make of the Gloucester Road?

We are disproving his theory. If everyone was driving out to these great big car parks at Cribbs or other malls they are also not helping with the pollution and congestion on our Road.

To anyone new to this road, what would you say to them? If they can afford to live in the area, what would you say?

Give yourself a few hours to just stroll in and out have a chat with anybody. It's just a really good way to get to know people and find out what's going on in your area.

The dentist.

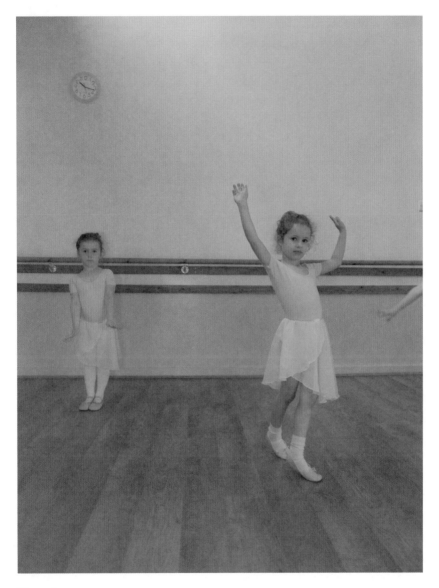

Three dancers.

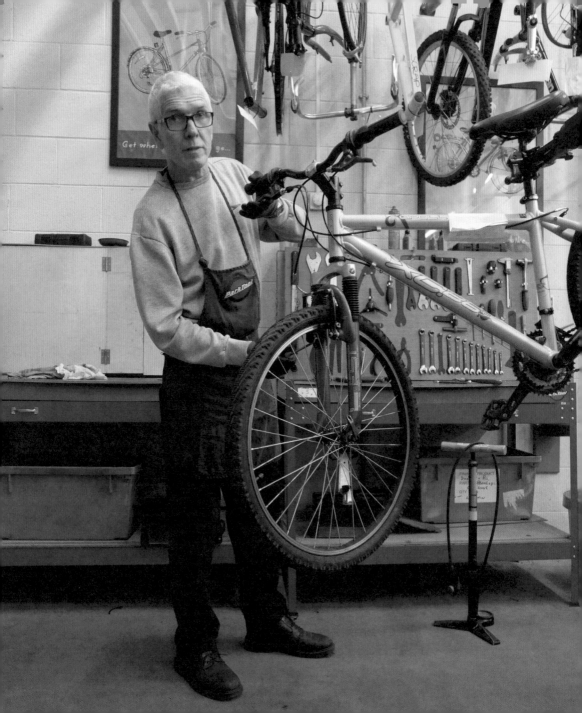

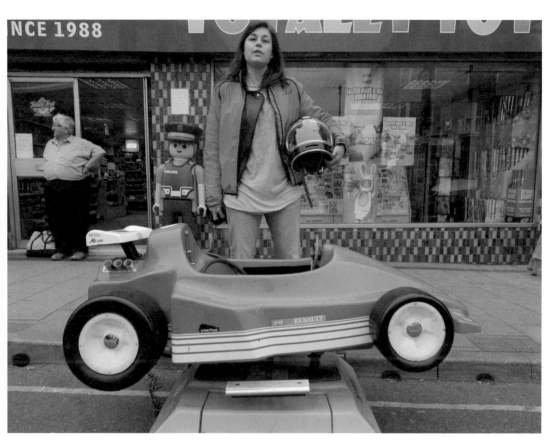

When I grow up I want to be a 1980s Formula 1 racing driver.

Opposite page:
Life Cycle UK workshop, HMP Horfield Prison. Innovative bicycle refurbishment project whereby donated bicycles from the public are stripped, repaired and rebuilt by prisoners and sold on at affordable prices, so lower-income Bristolians can get on two wheels.

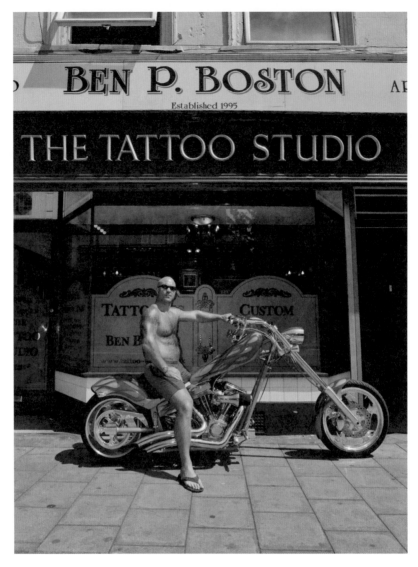

Adrian O'Connor with his Swedish-style chopper on the hottest day on record, July 2019.

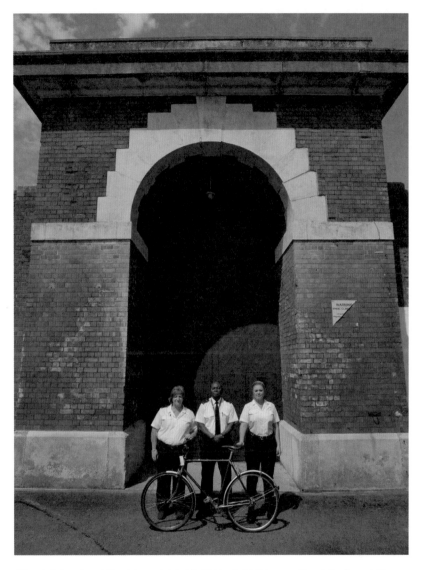

Alina, Michael and Patricia outside HMP Horfield Prison with a bike from Life Cycle UK.

David Clements, Bristol School of Gymnastics

Where are we?
We work in the old Bishopston Methodist Church on the Gloucester Road.

It's a very big, beautiful building. What activities run here, David?
We do gymnastics from the age of under threes, soon as they can walk, to pre-school classes, through recreation classes and, if they get chosen, they go through to our competition squad. We can train them for up to twenty hours a week.

If you want to be the best, you have to put the hours in then?
That's the minimum. Some of our girls do an extra two nights a week as well. They do the training to get to the level they want to be at.

Does it build team skills and confidence?
Yes, social skills, working with adults. Taking criticism and coaching at the same time. Teaches them to perform in front of other people. Working out there, on just a ten centimetre beam with hundreds of people watching, it's important. It gives them confidence. This country is top five for gymnastics in the world right now. We bought this place in 1996 and we were probably ranked fifteenth or twentieth. Now, due to good organisation and a change of leadership at the top, we have moved our way through to top five.

But why here on the Gloucester Road?
We moved here from Woodchurch Sports Centre. This seemed an ideal spot. We don't have to advertise, we are on the main road. Good passing trade. In the last five years I would say it has improved as a street in status. This end of the road is full of independent traders. No big ... what you would call them ... retail outlets. Perfect.

A lot of families choose to live here. What services are being provided for their children on this road?

When we first bought the place the community association were on our side. The building was going to be sold to be knocked down I think, to build flats. Like they did with St Michael's on the corner, which was sliding down the hill. We wanted to keep ... there is a great community feel on the Gloucester Road, you see, and parents want their kids to do a lot of activities. We cover that. Church next door is full of ballet and drama, we're full of gymnastics, trampolining and Tae Kwon Do. And the church is still in the house next door.

There are businesses that connect with each other here, then?

They have a playgroup in the church next door, they use our place every month as they are short of outdoor space. Everyone benefits when you cooperate.

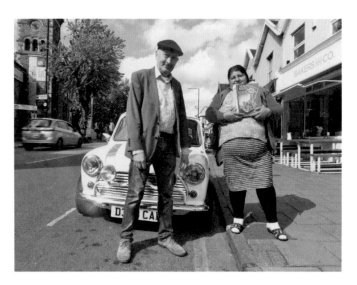

Two worlds meet – Ian and Marcheka.

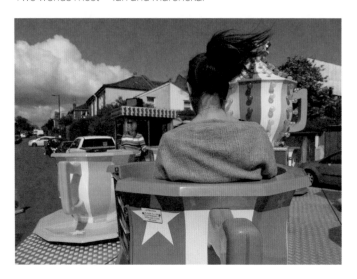

Heidi Smarts' teacup test ride: 'We love events like this, bringing the community together.'

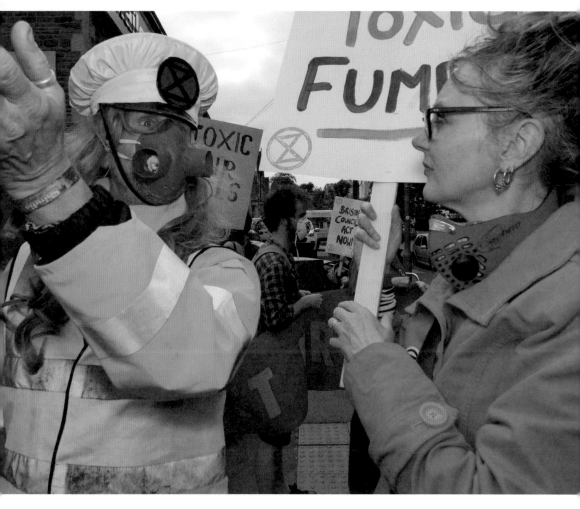

Extinction Rebellion toxic lollipop man blocks the road for a minute.

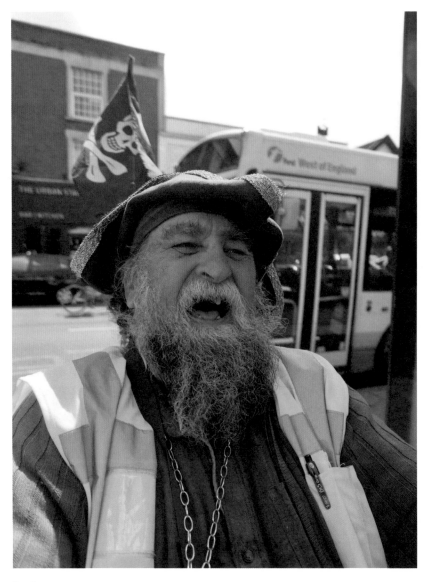

Cap'n.

Ice breaker at an Extinction Rebellion meeting.

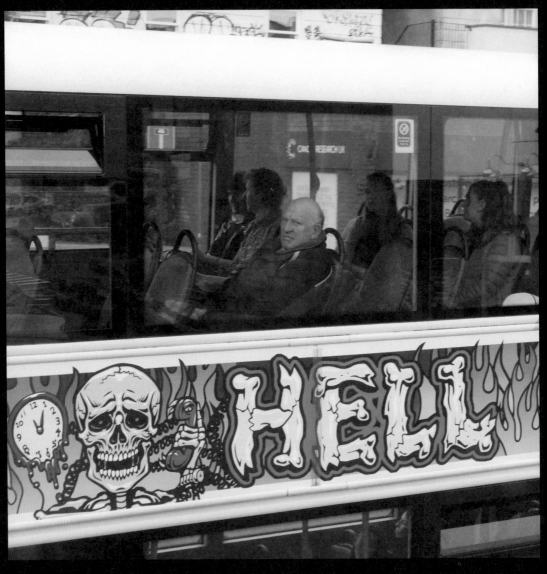

Hell

Opposite page:
Hell, Part 2

Extinction Rebellion are ready.

Opposite page:
Extinction Rebellion solo protest.

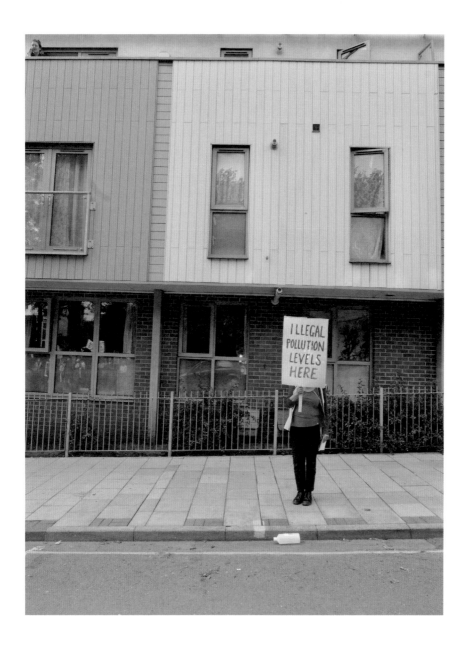

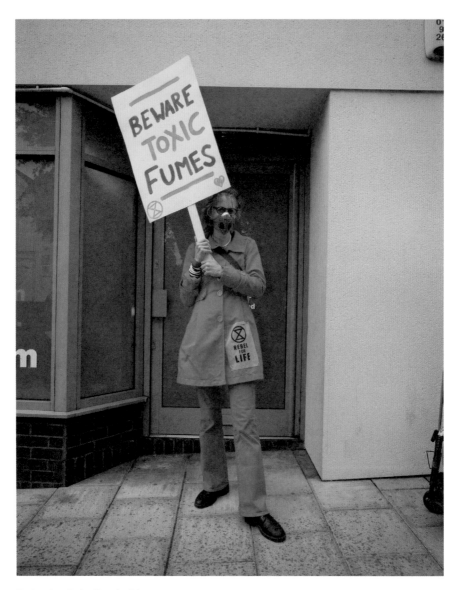

Extinction Rebellion fashion moment.

Extinction Rebellion 'we shall not be moved' rehearsal ahead of summer protests.

Ravinder Singh, P. D. Cars

Tell me about your business and your grandfather.

The long history is [that] Grandad came over just when the influx of Indian migrants came. His early plan was to stay for a few years. He is a farmer by trade originally. He worked as a labourer and quickly realised that it is a good quality of life over here. Brought the whole family over, so my dad grew up over here in Bristol. Dad pretty much started his work as a mechanic. Began as an apprentice, worked his way up to what you call 'master tech', or you might call a specialist, and decided later in his years to start his own business. He chose car sales, which later grew to repairs. Grandad always stayed in Bristol with him and used to walk all the way from Muller Road down here to Gloucester Road every day, and all the locals knew him.

It's one of those ... you always see an older Indian gentleman with a turban, everyone will recognise him. He passed away some fifteen-plus years ago and we even now still get the occasional person popping in to ask if he is still around.

I notice you have this empty chair and this bust, this figurehead on a plinth next to it.

It was done while I was quite young. It was a local artist who did it. Used to live near the Road, just came in one day while Grandad was here, took some photos. When grandad passed away we contacted him and asked if he could just do it.

Seems like one trade can support another then, even motor mechanics and a local sculptor. How do you see it working?

It's a little community, we all look out for each other. Shop within each other's places. Like you have Bishopston Tiles. I've got friends and family who come from London and Manchester to come here and buy tiles and all sorts. It's just that they know ... people give a bit more attention to detail, they just care.

Do you think this road will do better because we do mark the past as well as live for today and plan for the future?

Even now people who have moved away will come back and reminisce. What used to be here? What was here before? Conversations about when the Grace was the Robin Hood's Retreat. Everyone remembers, but it is interesting to see how from that it has grown. Keeps growing.

[Piara Singh tells the story of the bust inside P. D. Cars showroom.]

There was a guy who was just passing the showroom and my father was sitting on the chair and he said, 'That is a very interesting feature on the Gloucester Road.' So he asked me if he could take a picture and my father asked, 'Why are we taking these photographs?' and we just said, 'We are trying to find you a girlfriend.' So we sat him down in the chair in the middle of the showroom, so the guy took photos from all the way round. He went home and made the bust on his kitchen table. When father passed, I asked him to make one for me because everyone was coming in asking, 'How is your father?'

I myself ... built this company up from nothing. I was in partnership from 1978 to '91. That business dissolved in the recession of '89/90. And then I started on my own. We have our very own workshops, everything with my son. He is coming into the business now, he is running it. I've got four children and they are all bank managers, police officers and accountants. This one will go to him.

In the photo you shake his hand, like saying, 'This is yours in the future?'

Yes. Yes.

Green spaces workshop. Locals learn how to green up the walls and the benefit to us all.

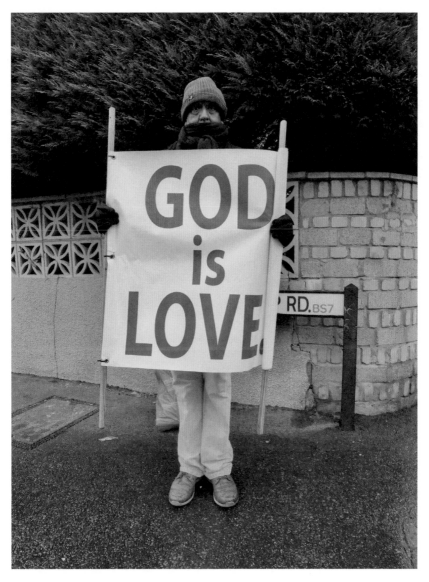

'God is Love' outside the Cricket Ground.

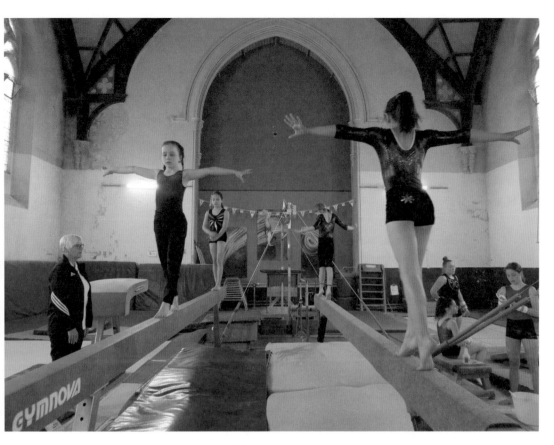

Bristol School of Gymnastics.

Opposite page:
Bristol School of Gymnastics meet and play.

Past and present.

Barbara, Osna

I've been here twenty years and I am just as passionate as I was when I started. I am continually learning, so that I can give the best to my clients. I love this road. The vibration here is fantastic, and we get on really well all together. I see my little centre as the little oasis in the desert. It's a place where people can come and chill, relax. Clients are amazed that everything is quiet even though all this stuff is going on outside. They can find a space.

Sometimes that makes them realise they can make a space for this in their own home. We need time to relax in our lives even more these days.

Do you think if people slow down and stop, they might connect more?
Maybe. It is what it is. People are becoming aware that in their busy lives they need to take time to stop and look after themselves. We've got a lot of cafés here, artists, and the whole ambience of the street is lovely. People come from London and all over Europe and they notice. They see this as like a little village, almost. And we made it, working with what we have got.

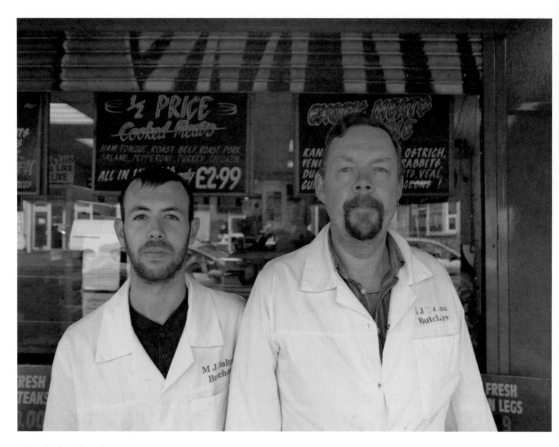

M. J. Dalton Butchers.

Opposite page:
Cliff Trott, taken on his last week before he retired from running Hughenden Road Garage after forty-two years.

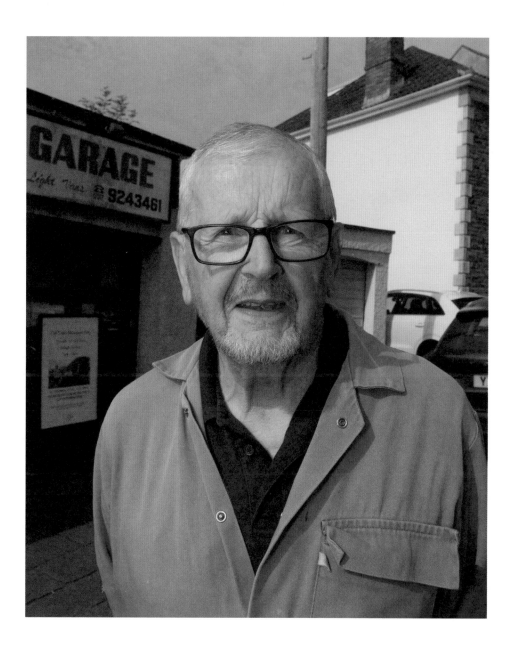

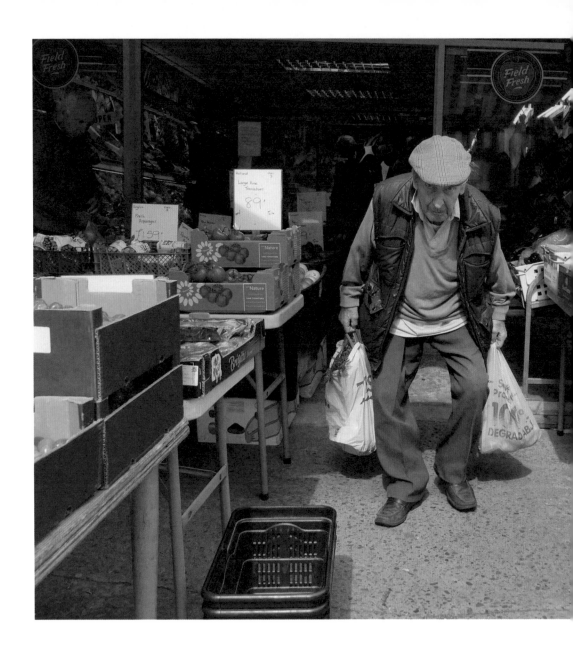

Hamlin on a fruit-and-veg run at Pawsons: 'I drive down from Southmead to get what I need from here, they always have what I need. Every time. And it's often four days fresher than in the supermarkets.'

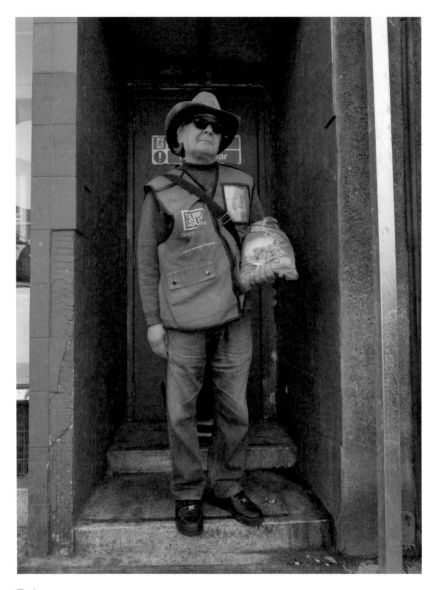

Tudor.

Enso Alex Millest performs Shaolin Kung Fu: 'I went to China to get away from the west [and] to learn martial arts.'

Michael at Area 51.

Opposite page:
Saraj Qurbani, Brunel Tailoring.

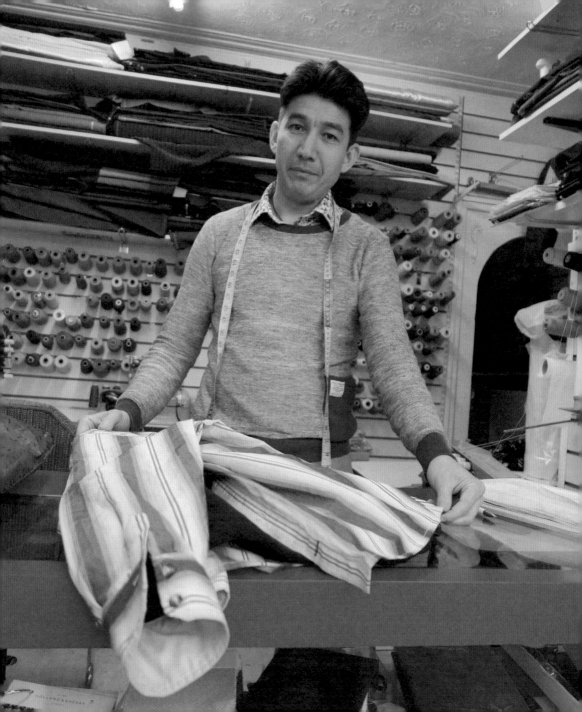

A&E Hair and Makeup Studio girls.

Diana, YogaWest

We are a yoga studio. We have twenty-two teachers of Iyengar Yoga. Thursday morning's women class is the one you have shot, that is a very popular class. It is a lovely space to have some fun together."

Where does Yoga fit in with the Gloucester Road indy spirit?
I can't think of any yoga practice here that isn't independent. It is a great fit. A lot of the local traders come to us.

One trader never exists in isolation on this street, it's a web. There are hubs also where they meet. Are you one of those?
The road itself is supportive like that and we do see it here. Oddsocks and others come and here be ... quiet. You can join together here. It is not necessarily why people start yoga. They have [m]any reasons. But the secondary benefit is when they start a regular practice. People come and at the start there is a real buzz. Shopping in tow, bikes. And you see the same people coming and after go off into the garden, have coffee together. Most walk here. Most are local.

Ok. Now I see your logo – the lotus flower – and they say it thrives in polluted waters. Give me your thoughts about what you are doing here, around the symbolism of this flower.
The lotus has many petals: it has eight sides. These eight limbs, an eight-path journey through yoga, are very important. Our logo is based on the mandala shape. The circle for us is people coming together. It is about the circle of life, the circle of your pattern of life. Day to dusk. Birth to death.

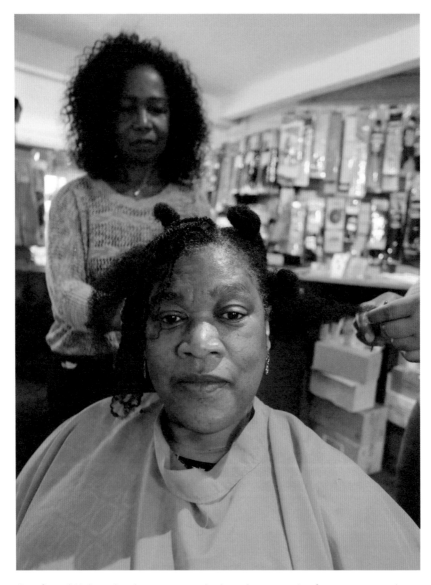

Comforts: 'We have loyal customers who have been coming for twenty years.'

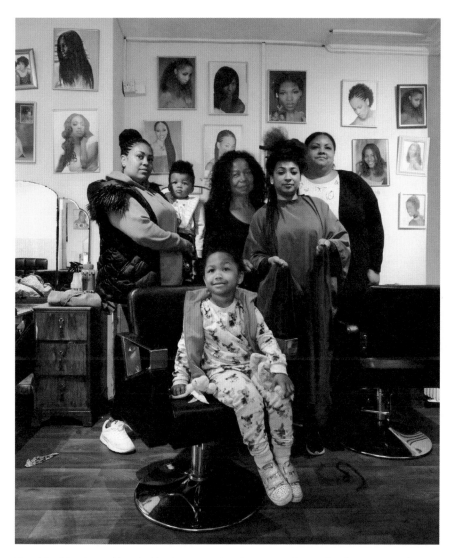

Tayshia, friends and family. 'I've been coming from out of town for five years and Comfort is the only person who can get my hair right.' Some of those being served today are having their kids' hair done for the first time. 'It's a generational thing.'

Sarah at No. 212. The art is 'Bristol Houses' by Jermal Gugunava, who has left the area but wanted to represent the road in art before leaving. It was Sarah's idea to do a book like this of the Gloucester Road.

Paul, Totally Toys

Since I have been here, I've learnt a lot about the people around me. How much people want to live near the Gloucester Road. Personally, I want to be away from the shops and the hustle and bustle. But it's a real key driver. And estate agents would back that up. House prices around the Road are all good on both sides.

There are so many terraced houses off the main spine, aren't there?
Oh, yes. And they fetch some crazy prices. It's handy. It's a 15 minute walk to the city centre. You get a lot of people coming from London who see Bristol as a good place to come. It's not that different. Lots of things going on. Not a twenty-four-hour city but as close as you can get this [far] out of London. When I came here, I took a twenty-five-year lease on the shop and now they take three- or four-year leases and they say, 'I wanna have a go.' Some come and it doesn't quite work out for them and others stay a while longer. Like food shops and restaurants. There are [*sic*] a massive amount of them. I had an idea of us all putting our flag up of our nationality. It's the United Nations of food here.

You told me the first time I saw you that there were three tiers of shops you need to make the high street work. Remind me, what are they?
Tier one: cornerstones, food shops - we all need to eat. Bread, meat and fish. That's the foundation. Then you need destination stores and businesses. Electrical shops, DIY stores, haircuts. You name it, it gives the flavour to the whole street and makes people come. But then the third tier: coffee shops; pop in, stay a while. These make it more fun. Have a coffee and hang around. Pause all day. That is the Gloucester Road.

Will suffering ever end?

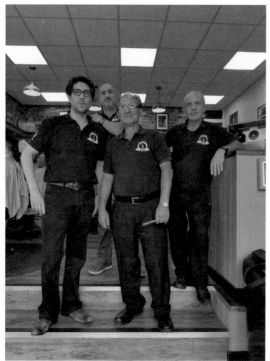

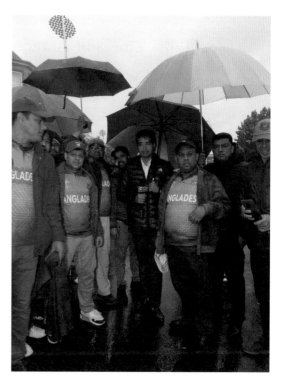

Vincenzo [*centre*] with family, friends and customers. He came to the UK from Sicily in 1963. The harsh London winter nearly made him head home, but a friend invited him to Bristol and he never left. They extend their gratitude to the community.

Bangladesh fans in the rain with Salahuddin Muhammed from Jamuna TV, outside Gloucestershire Cricket Ground, Cricket World Cup 2019.

Nigel Clifft, Emmaus Vintage

Tell [me] how you ended up working here, Nigel?
I work in the Emmaus shops, Bedminster, Stokes Croft, Vintage. I do all sort of things. I come [*sic*] out of the RAF and I have been in Bristol since 1989. I worked in a hotel in Frenchay when I left the RAF and things did not go right ... for various reasons. And I ... have, roughly for about a year and a half/two years, been street homeless and sofa surfing in Bristol. Then, in 2003, I heard about Emmaus opening in this town. I phoned up the manager there. He said to come in to do an interview. It had to be a referral system. It seemed all right. And at the time I thought this is good temporarily and well ... I'm still here.

What made you stay?
No one judges you about your past [or] misendeavours [*sic*], whatever they may be. I came as a companion. Then I became a responsible companion. Then a community assistant, which is more responsibility. Then I became a staff member. Now I'm back as a companion again these last two years.

When you see other people coming up, who may have been through a story like yours, what is that like? Meeting them? Helping?
It's good that they have found Emmaus. We can help them out and give them support. Not judge them, meet their needs. They are in a safe environment. Giving people a bed and a reason to get out of it, we used to say.

What does this road mean to you?
I like it because it's indy. The real Bristol, as it should be and as it was. We don't have the big chain stores. It's good that independent people are trying to make a living for themselves in their local area.

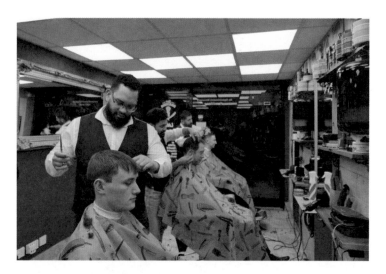

Buzz, razor and scissors at Lana Barbers.

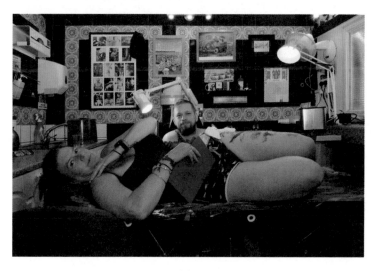

Ben and Jo at The Tattoo Studio. '[It] Used to be a butchers, some say it still is ...' jokes Ben. Check out Ben's artwork of the entire Gloucester Road next time you are in.

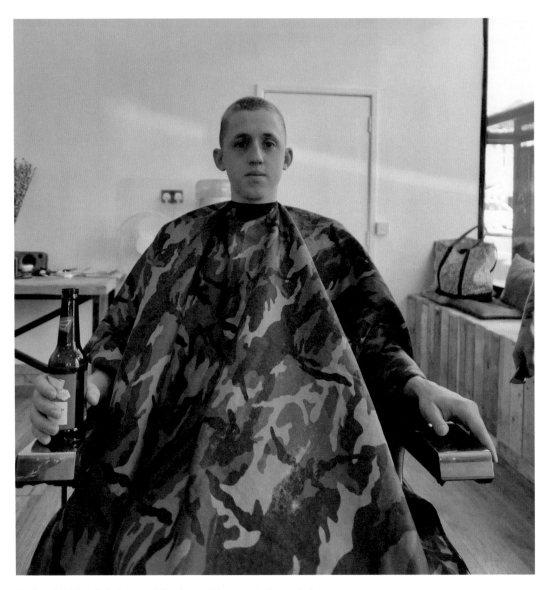

Bud and Eddie of Harlow and Co.: 'Love this street. It's quirky.'

Tim Franklin opened in 1980. He began by selling pool tables to the public. 'I supply all the prisons, all the places people get locked away: youth clubs, community centres. You have to give them something. It matters.'

Anne-Louise Perez, community advocate

Tell us where you fit in here on the Gloucester Road …
I'm a local resident, but I've always had an interest in our high streets and the importance they play in our communities in bringing people together, providing our shopping, services and more. They are the heart of the community. Without our high streets, where do we go? I've worked for years supporting mostly independent shops, but also recognising we are a modern world. Recent work I was involved with was for the business improvement district here, and my role was to look at the high street and look at the future of the high street. How we need to adapt to keep our high streets going.

What could be the future for this street? Aldi and Lidl have just opened big stores nearby. Will that effect the grocers and other trades on the street? Are there potential trouble spots ahead, as well as opportunities? And what about the pollution?
Gloucester Road is renowned for its pollution, but we have events like one last week to recognise Clean Air Day [20th June], and that was a really good example of community coming together with local businesses. A local café was able to put on the event: they had Travel West; they had cyclists there; maps being shared; free breakfast for cyclists, so out of that negative of pollution people were brought together, raising awareness.

When you do get supermarkets coming in like Aldi and Lidl, they were brought in to meet a need in Lockleaze, mainly. I would not be surprised if it had an effect here on the Gloucester Road on our green grocers, our butchers, but these businesses here do have a really loyal following. For me it's about adapting and going, 'Ok, what have we got that those big stores can't do?' What local shops have is personality. They really need to work that, that customer service. And then

there are people who are doing experiences. Our high streets have always been destinations, but more and more people want an 'experience' to take photos and put them on Instagram. For me it's time to adapt. The fish man, for instance, he could do a fish-filleting hour[-long] course in the day, show people how to fillet a fish. Get to the haberdashery, Flo Jo's, they are always running little courses.

Are these where a crossover occurs between the businesses and community? Blurring the boundaries? Threading all the elements together? Making it work?
Absolutely, and you have got to give reasons to your community to want to come down. Because … the consumer is changing. It's more experience-led now than product-led. They will buy your product if they have a good experience. Adapt.

In media and social media there is a change of late. People want authenticity. Local stuff, and an integrity to what they are buying. Instagram imagery of a perfect life, that's not so big now, people want something … real. That's here, is it?
In Instagram often everything does look perfect, but you know what I say is, come down to the high street, experience the real thing, see a bumpy apple with a bruise on it, see things that are normal. They may not always look perfect, but they are absolutely delicious [and they come] with that great customer service. Butchers might throw in some sausage making. Something like that, which is fun. Also, these events held here attract younger customers as well and they may pass [it] on. It makes it a place people want to live. Here on the Gloucester Road we have everything on our doorstep. From key cutting to getting your fish to fresh bread. We have a couple of mini supermarkets, they provide a service because they are open till ten/eleven o'clock at night. There is a place for everyone, but finding that balance.

Books for Amnesty. Read, and think before you speak.

HMP Horfield Prison: officers, Life Cycle staff and customers prepare to be photographed.

Cliff Trott, [retiring] running Hughenden Road Garage

In the last week of the book preparation, just before the deadline to send everything to the publishers, I got a message from a contact who simply said, 'Go see Cliff Trott, Hughenden Road Garage, off Gloucester Road. He's retiring this week after forty-two years. He has operated out of the same small shed that used to house cows up by Horfield Common for decades and he has a superb calming effect on everyone.' So I did, and as I walked up to his garage he apologised for the mess, as he was shutting down and there was just a huge collection of parts everywhere. He was feeding a neighbour's dog with biscuits and water and was happy to stop and chat once the dog had had its fill.

You've been here for forty-two years, Cliff. Biggest change in all that time?
Traffic. Less and less, believe it or not. Over the last ten years so much less. This road is not the road it used to be.

Many traders here say they are concerned about how hard it is for cars to stop and buy along the road at key times, and yet you say it used to be busier and a mess ...
Yes. For argument's sake, it used to be only crossable at the traffic lights. Now nine/ten times you just look both ways and pop over the road. Easy.

What's changed long term here?
The reason traffic has gone down is that we have lost the industry that was around here. No matter where you go in Bristol [it] had an industrial past, Bedminster had Wills Tobacco ...

[At this point a neighbour passes and blows Cliff a kiss. I beckon her to come over.]

Hello, who are you? And why will Cliff be missed?
I'm Isobel and I live round the corner. Lived here for about ten years. And when I can't do things like shut my bonnet on my car Cliff has never laughed when he has come to rescue me. He's funny, smart, informed …

But he's going …
I know. It makes me sad. My generation are [*sic*] not going to be here much longer. It's really important that this place right here and now is recorded: our absolute love and confidence in this street, that all this continues, it's really important and significant and part of what we call community.

Cliff, your thoughts?
It's because we have lost the industries. That's the key change. All over Bristol.

But moving from an industrial past to this consumer economy, well that's just progress isn't it, Cliff?
Is it? Cars have changed. When I first started here we were able to take pieces off and repair them and put them back on. Now you can only throw away. For me this is an unfairness to the world. The reason we have a great demise of places like East Street in Bedminster and Gloucester Road and Stapleton Road is because there is no industry. BAC employed tens of thousands of people. Those people had to go wandering up Gloucester Road and that is why so many shops grew there.

So can we learn from this past to make the Road successful and healthy? The Road seems to be thriving now.
It's the wrong shops for a successful street. You used to be able to buy a suit of clothes and three to four shops to choose from for every business.

With 'make do and mend' aren't we seeing a rise in this kind of business? Flo Jo Fabrics teaches the skills you need. Are we going back to basics?

Maybe. Hmm. But the footfall isn't there. Not how it was. People drive through, and so few can stop. I live in Whitchurch, only eight miles away, and it takes me an hour or more to get here every morning. Traffic. I can remember when I was walking delivering the papers that people from Knowle were walking down through to Bedminster to get in to Wills and there were thousands of them, more than when there was at a football match. It was the same here.

What advice would you give to someone who has just moved here?

The world is gonna change quicker than we will. What is it these days? Everyone just looks up and gets their answers from the clouds. Look around you. Down here. This is where the answers are.

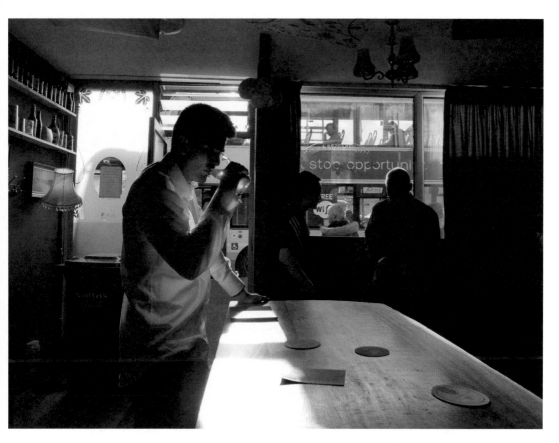

6:04 p.m. Drapers Arms, stop! Opportunity ...

Opposite page:
The regulars of Drapers.

4:15 p.m. Beer check at the Drapers Arms, by Garvin Hickey co-owner.

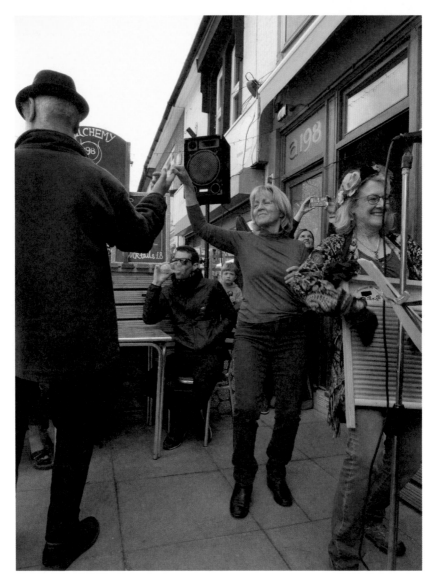

Alchemy.

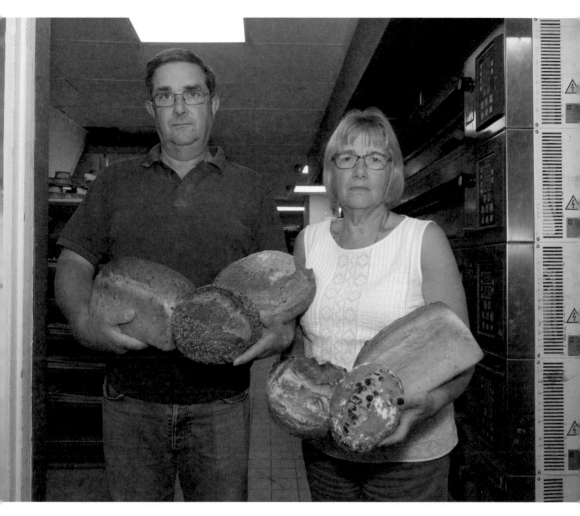

Martin and Jane with their favourite loaves.

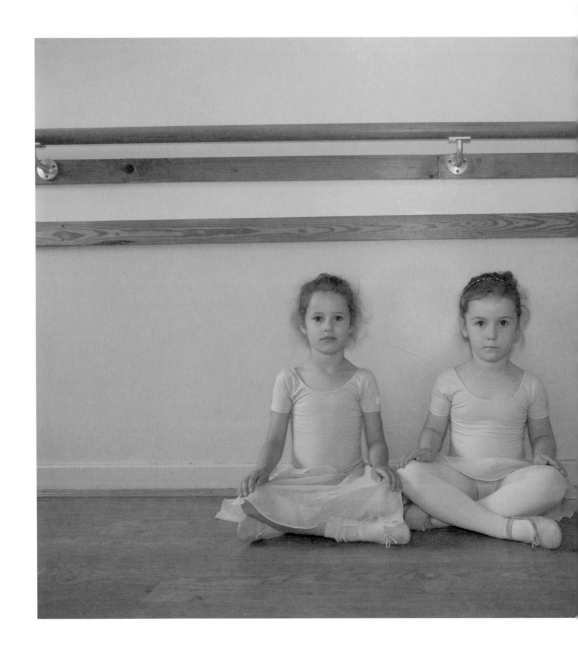

Annette Adams School of Dancing. The young dancers take a pause before rising to the bars above.

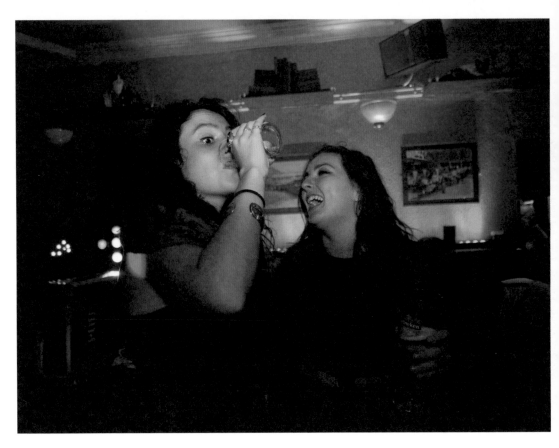

22:01 p.m. Cat & Wheel.

Opposite page:
Ian and Nikki two seconds before their first note at the Cat & Wheel karaoke.

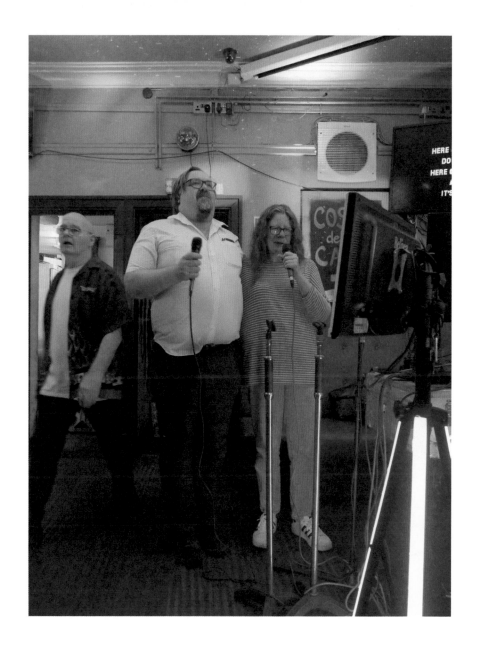

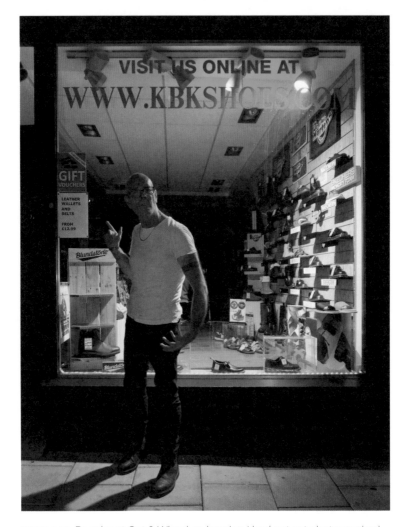

22:37 p.m. Regular at Cat & Wheel on hearing I had not yet photographed KBK Shoes. He puts his pint down and takes me there. 'Look. There. This place matters. People from all over the world get their boots from here. It's been right here for decades. Put that in your book.' Click. Smile. Then back to finish our pints.

Martin and Jane, Joe's Bakery

Tell me how you came to be here on the Gloucester Road?
Jane: Martin and I were both born and brought up in this area. As children we played in this area. We got married, Joe's Bakery had been part of our life since … well over sixty years. We went into the bakery trade in 1986 and when the opportunity came up in 1990 to be part of this bakery, we jumped at it. So, we came to the street. It was not in as good a shape [then] as it is now. But there was more diversity in the range of shops at that time. Four or five bakers, five or six butchers, greengrocers, and it has evolved over the last thirty years, through ups and downs, into what it is today. Although it's not as diverse as it used to be, it is much more vibrant than it was. There are a lot of charity shops. Good or bad. More importantly than that, the area has grown into a very socially aware space. The people who live around here come from all sorts of backgrounds. That adds to the vibrancy and the success of the road. Good trade associations help. They promote us, and we try to capitalise on all these good things and give back to the community in a big way. Give back by helping all the traders survive.

Was there a store at the other end of the street that was struggling and you stepped in?
[Martin walks in at this point to join us. Jane picks up where she left off.]
Jane: So, The Bread Store had been down there since the early 1990s. A very successful bread store. There was healthy competition between the two of us. It's good to have another bakery on the road. For whatever reasons, they decided to call it a day rather suddenly and close. We had the opportunity of stepping in, so we did. Two reasons: it needed a bread store presence that end of the street; and it was good for us.

The queues outside your shop on a Saturday morning are long. I was going to photograph it, but I couldn't fit everyone in the shot.
Always long queues this end.

For a while in the 1990s it seemed like the big supermarkets were referring to the high street as being dead or dying.

They could have gone. A lot of them have. Gone. But we owe an awful lot to the public who live round here that value their local shops. Without them we could not do anything.

A lot of businesses seem interdependent on each other too: there is a blacksmith by the petrol station, and they make tools for sale in the hardware store. It seems we have reset back to a decent start-up – almost medieval essentials, plus lifestyle add-ons. The lighting shop is making light fittings and accessories here in Bristol, not just boxed up and ordered from China to sell on the shelf – keeping the cash in the city.

Brilliant.

Do the kind of people moving here now have to be monied to afford the house prices?

Now it is professionals. Yes. There is massive exodus from London to Bristol. These people are taking advantage of selling houses for a lot of money in London and coming here to buy a lovely old Victorian house. And they like living in communities like this. But there is still an awful lot of ordinary hardworking local people. We get people coming down from all the estates around, from Lockleaze, Southmead.

I met a man who drives his car down from Southmead every week to get his fresh fruit and veg from the grocers just a few doors down from you.

Through history and diversity, this is still a vibrant community.

I notice that you travel all over the world to learn about different bread techniques.

Well, mostly Europe. Oh, and America.

What good bread is there in America?
Not a lot.
[Martin joins in now]
Martin: Except sourdough, and ciabatta came to the UK from America, really. Even though ciabatta is technically from Italy, the Americans really made it popular.

Sourdough is so big in Bristol.
Martin: It's huge. A big sea change started about forty years ago. Whereas people had been moving away from the area, people realised what a great place to live it was and started to move back in. That started the house price rise. Then there were more local shops. We have good pubs, [and] it is on the bus route into town. You can walk in from here if you want to. These people have supported the businesses. Old and newbies. The public are so supportive.

Frasier at Ablectics said he would never close his electrical showroom shop on the Road no matter what, and from our conversation it seems business is secondary to community.
Martin: We always had a good community. It did start to weaken ... a while back. It started to strengthen again quite soon after. Wealthy homeowners in the big houses started to move out to Stoke Bishop, to Chew Magnor, but it was not terribly long before switched-on people started to think they'd rather live here, rather than the middle of nowhere. Pubs, shops, easy transport links.

At the core, what is it that makes you tick personally Martin? What is it about bread?
It's the stuff of life, bread. You can live on bread and water. Or live well on bread and milk, a few beans. It is a good, core food. There are groups starting to dispute that, but my way of looking at it is that we have been eating bread for about ten thousand years or so. Five thousand years of fermented cereal products. Mainly wheat. And we seem to have done OK on it. Wheat and rice is [*sic*] what the whole world eats. But that's not the reason I am passionate about it. I am a

production person on a craft scale. Before bread I was in the ice cream trade. When I came into the bakery, I loved straight away how you take some few simple ingredients and produce a nice fresh food from it every day that people really enjoy. Sourdough was not around when I first started baking. Seeded sourdough, that's my favourite. When you are on the development trail like we are there are so many new things to look at and develop, some work.

I see families come into your shop and other shops like it. How do you make so many different lines of breads and cakes?
Martin: If we can do volume and that supports some of the speciality ranges, then we do it.

Your passion for the Road is obvious. Is bread a metaphor for the life of the Gloucester Road? From all these simple ingredients baked together, something wonderful rises. Or is that me digging too far?
You have an artistic mind!

Ok. What would you say to someone who has just arrived and is about to walk the Road for the first time?
Come early in the morning, when the air is fresh and smell the air – not in the bakery, out on the street – and you are hooked. Even now after being here for nearly thirty years, I still love the air out, it's so fresh. I can also smell if they have burnt something, by the way.

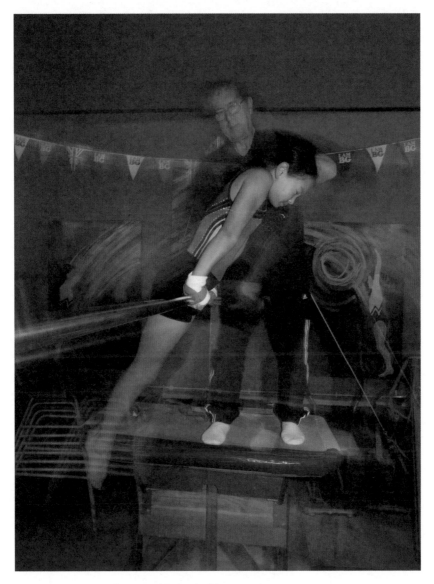

Evening practice at the Bristol School of Gymnastics.

The dancers, part two.

Opposite page:
Dancers at the dockside Latin Orchestra crowdfunder event.

Cleo Lake, former Lord Mayor of Bristol (2018/19)

A butcher, a baker (the sourdough maker)
A barber, a bookies, a Mosque and a morgue
The high street is a place I love 'like sliced bread' (well, if you can get a loaf sliced these days) and carries a spirit that cannot be found or bought in a shopping mall or retail outlet.

During my term as the mayor of Bristol, I was able to visit high streets less familiar to me in Westbury, Henleaze and Hanham, as well as very familiar locations like Fishpond's Road, Lodge Causeway, Stokes Croft, Gainsborough Square Lockleaze, Church Road, Filton Avenue, Stapleton Road and my local Grosvenor Road. For me, the high street is a community hub – it is the epicentre of a community, both indoors and out, free of charge and needing currency, open and closed. Reminiscing on the Stapleton Road days of my childhood with places like KJ's everything store, Centre Court Sports, Hummingbird Books, some stores went without name and were simply known as 'next to Marina's', W. F. Buss veg shop laid out local produce in mirrored lanes, and Mountstevens bakery displayed sugary snack temptations in the shop window, like 'naughties' on the newsagent top shelf or the penny sweets in a white paper bag. How many did you really have in there?

No longer restricted to a run of shops, the essence of the high street is a place where you meet, make, do, avoid, prepare for birth, death and shop. It can be a square, a rank of shops, or a long, sprawling independent. Each place has its own character, although surely no high street is complete without a hairdresser (possibly with a comic title like Headcases on Charlton Road, in Brentry), a betting shop (or lottery outlet), a chemist, a chippy, a meat shop and somewhere to buy veg? The rhythm of the high street is that of the community, whether the long-term residents and stores, the transient and 'trier trader', or the visitor. You nearly

always find what you need, what you want and what you didn't know you wanted: gems in hardware stores; and bit-of-old-tat shops; or rose-jam-filled donuts hidden behind posters on a Polish shop window (also selling reasonably priced sliced sourdough bread!).

The high street might be neat and cared for, maintained with acquired vintage lampposts, hanging baskets, Christmas trees darting from walls and window wonderlands. Or [it could be] clunky, mismatched, alternative and real, where a national chain is neighbouring the bizarre and unpronounceable shop signage sponsored by Digicel, Happy Shopper, Lifestyle or Coca-Cola, and where shopkeepers double as advisers, moneylenders and counsellors, a 'problem shared is a problem halved' after all, but the same probably can't be said for the grocery bill!

High streets transform and alter with changing priorities, status and communities. We now have Somali and East African eateries and 'hang-outs', and nearly every high street has at least one Caribbean food shop, or a Middle Eastern Muslim barber or a kebab shop. Many butchers in Easton where I grew up are halal, with local chain Pax leading the way, but old favourites – the English family butchers, Sid Purnell and R. Jenkins – are still well loved and supported, and stand inclusively proud on Stapleton Road, whereas Brittan's pork butchers down the road in St Jude's/Lawfords Gate recently packed in the pork pies and closed after a 200-year old legacy.

Newsagents, post offices, red pillar post boxes, public telephone booths and their users cling on to a tangible and tactile existence in spite of the mobile news updates, the email, the WhatsApp message and the online banking.

This changing demographic and technology plays out and rubs against old England in a kind of motley crew of culture, carving out a future collective identity on the wave of time. The High Street is a living museum, it rises it falls but it is never half baked.

Gloucester Road, one final story. Last night a taxi driver saved my life.

This is a transcript from a conversation in a community space on the Gloucester Road. People referenced have asked to remain anonymous.

I was talking to this elder [*sic*] gentleman who was working in a shop here and the pain in his abdomen was so bad he closed the shop and started to walk down the road. The pain kept on increasing, so he went up some steps into the minicab office and asked if he could be taken to the Montpelier NHS Health Centre. The taxi driver got him in the car and started to drive. When he got to Bath Buildings he should have turned left, but he didn't turn left he carried on. The elderly man was very upset, and in such pain, [he] was so angry and could not understand why he had not taken the left turn. He was taken all the way down the road to the Bristol Royal Infirmary. The taxi driver, who was from overseas, told him that he was a doctor and that he recognised that he needed urgent surgery, which is what he had and it saved his life.

When he recovered he returned to the shop and wanted to thank the driver, so he went to the taxi company with a big bottle of champagne. Alas, he was not there that day and another driver said he was very sorry, but that he knew he would not be able to accept alcohol.

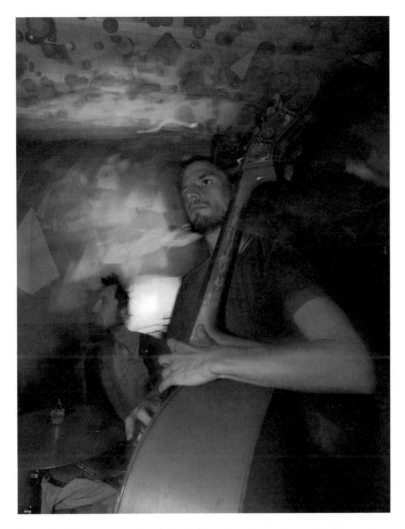

Snazzback bass and notes at the Gallimaufry. James Koch, "Galli' means 'hodgepodge of leftovers eaten on long sea voyages'. This place was set up with so little money with high hopes for a community-focused place, a caring place.' The metaphors in the trades of music, sewing, food and more on this street relating to rivers, ocean voyages and flowing keep coming up.

The celebrants who speak at many of the Gloucester Road funerals and ceremonies. Lives are like rivers: they change course, cut new paths, meander on their way, but these people here will be there at that final bend.

A short summary from Alan Bec FRSA

This book allows us a rare chance to consciously connect to the surroundings that make the street culture here so significant. It is explicitly clear that 'human connection' is more than a set of attitudes or behaviours – human connection is a place. There is no doubt that the traders don't just make their living here: they are Gloucester Road, and we are welcomed to take part.

There is a flashlight way of seeing and identifying with the people that causes me to look more, to dwell that bit longer on each portrait. I'm immediately transported to the conversations I have had here, to relive the impressions of connectedness that they made on me. With each memory, I'm flooded with the unmistakable sounds and feelings there. It's the diversity of expression, a collaborative and inclusive street language that makes it the open, shared space for appreciating community life.

From my own experience of the place, there is as much similarity depicted here as there are differences. This road is a community, bringing us closer to ourselves and simultaneously to each other. It's an ecosystem of eternal human values. Having a 'chat' while shopping here gets remembered, relived and updated with each subsequent visit. It's about human connection. The road is a living life library – the source is its energy from its people. There are deeper interconnected interactions to which we can all relate to, learn from and act upon. This book's images and text serve as an implicit manual to co-create something mentally, emotionally and physically significant – our wellbeing.

Alan Bec M.Ed. (Psych-ed.), PGCE (PCET), FRSA